LUNCHBOX

LUNCHBOX

FROM COMIC BOOKS TO CULT TV AND BEYOND

JACK MINGO ERIN BARRETT

HarperEntertainment
An Imprint of HarperCollins*Publishers*

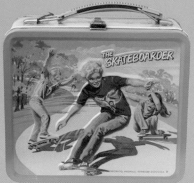

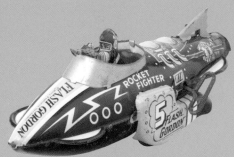

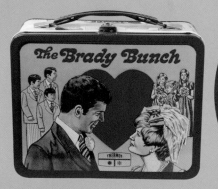

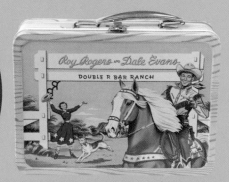

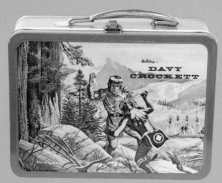

CONTENTS

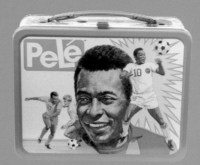

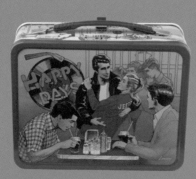

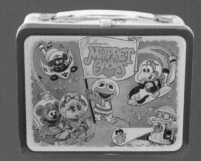

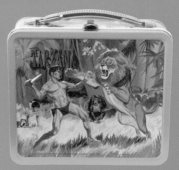

INTRODUCTION:
POP GOES THE LUNCHBOX

For children who lived during the golden age of lunchboxes, choosing a carrying case for your peanut butter or bologna sandwiches was more than a practical decision—it showed who you were and who you aspired to be. Pretty-in-pink girls carried a Barbie box. Tomboys, who looked to a tougher set of role models, went for Charlie's Angels. Boys carried Roy Rogers, or Buccaneer, or Rambo. Little kids carried H.R. Pufnstuf or Scooby-Doo. And the completely clueless? Generic plaid.

During the nearly four decades that marked the height of their popularity (the early 1950s to the mid-1980s), lunchboxes were a way to advertise your tastes—your favorite band, TV show, movie star, or cartoon character—as well as your personality. Most of the preteens who carried them, however, had no idea just how long it had taken for their colorfully lithographed metal box to evolve.

Long before the pop lunchbox, there was the working-class lunch pail. (And before the lunch pail, there was the oiled goatskin—but let's not go back that far.) The lunch pail wasn't really a pail; it was a latched case of toolbox-grade metal that would protect your noontime meal from minor catastrophes, anything from a falling hammer to a small hurricane. And they weren't chic. On the contrary, they stamped you as so working class that you didn't have the time, freedom, or money to go to a proper eatery for a decent meal.

But despite the pail's lowly status, working-class children wanted to emulate Daddy. In the 1880s they created their own school "lunch pails" out of colorful tin boxes that had once housed biscuits, cookies, or tobacco. From there, it was a small step to a box specifically made for children, and in 1902 the first true kids' lunchbox came out. No, it didn't feature turn-of-the-century pop culture idols like P. T. Barnum, Buffalo Bill, or the Sousa Band. Shaped like a picnic basket, it sported pictures of children playing.

THE LUNCH PAIL WAS A LATCHED CASE OF TOOLBOX-GRADE METAL THAT WOULD PROTECT YOUR NOONTIME MEAL FROM MINOR CATASTROPHES, ANYTHING FROM A FALLING HAMMER TO A SMALL HURRICANE.

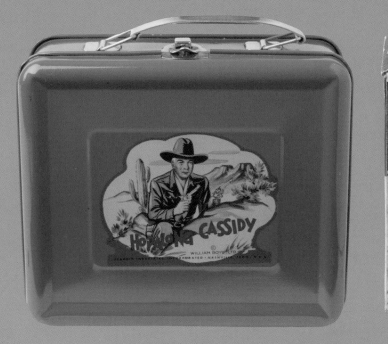

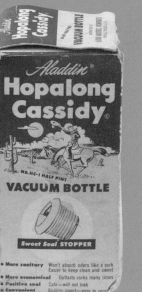

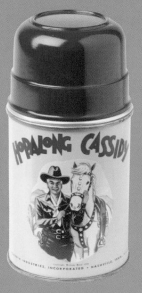

In the decades that followed, several other trial balloons were launched into the atmosphere of schoolhouse lunch gear, but it wasn't until the 1950s that the lunchbox really entered its prime. The heyday was brought on through an act of desperation by the Aladdin company, a lunchbox manufacturer. Although the postwar market had created a demand for all kinds of consumer goods, metal lunchboxes were so durable that they could last a kid from kindergarten to high school graduation. Staring at charts of slumping sales, Aladdin execs started throwing around ideas: "We've got these plain boxes—why don't we jazz them up with decals?"

"Kids seem to like cowboys and Indians. How about using a TV cowboy?"

And that's how Aladdin stumbled into the world of "planned obsolescence," a marketing ethos that would drive the American economy for decades thereafter—convincing customers to habitually replace perfectly good products for the sake of novelty and style. Aladdin hired a designer to sketch Hopalong Cassidy onto a decal, which they slapped onto the side of a red lunchbox. On the strength of that crude prototype, they convinced department stores to make advance orders, and Hopalong Cassidy took off.

"WE'VE GOT THESE PLAIN BOXES— WHY DON'T WE JAZZ THEM UP WITH DECALS?" "KIDS SEEM TO LIKE COWBOYS AND INDIANS. HOW ABOUT USING A TV COWBOY?"

Meanwhile, back at the ranch another cowboy star was fuming with jealousy. Roy Rogers wanted his own box, but Aladdin had turned him down: "One cowboy is enough" was the reason they gave. So Roy saddled up and rode north to American Thermos in Connecticut. Like Aladdin, American Thermos had seen sales slump in its lunchbox and thermos sets, a downturn made even more acute by Aladdin's Hopalong success. So they took Roy Rogers up on his idea, and did Aladdin's cowboy box one better by using bright, full-color lithography on all sides of the box instead of a decal on just one face. It worked: the company sold two and a half million Roy Rogers and Dale Evans boxes in 1953, increasing their total sales by twenty percent in one year.

ALADDIN HAD TURNED HIM DOWN: "ONE COWBOY IS ENOUGH" WAS THE REASON THEY GAVE. SO ROY SADDLED UP AND RODE NORTH TO AMERICAN THERMOS IN CONNECTICUT.

Aladdin quickly responded by also using full-box lithography in its line. So did newcomers ADCO Liberty and Universal, as well as another old-style lunch pail manufacturer, Ohio Arts (which later diversified into making toys, such as the ever-popular Etch A Sketch). In 1962, Aladdin added another trademark feature: designs stamped into the metal, creating a 3-D effect.

The next thing to evolve was shape. Square boxes were great for their TV-screen-like dimensions, but the highest artistry went into "dome" boxes, which had rounded tops echoing the original workingman's lunch pail. Though now much sought after by collectors for their designs, domes were introduced originally as a cost-cutting measure.

Lowering overhead became necessary because of the astronomical costs of buying rights to licensed characters and TV shows, some of which would inevitably be canceled before the box had a chance to sell. In the late 1950s, Aladdin started casting around for ideas to lower costs and hit upon producing a series of generic boxes that didn't require buying rights. The dome shape was thrown in as a novelty selling point. Lunchbox artists rose to the challenge, making use of the bigger canvas and thrilled at being freed of the tyranny of having to please temperamental TV producers and finicky stars.

Aladdin's first dome, the Buccaneer in 1957, capitalized on a pirate craze that had been spurred on by *Peter Pan*

DISNEY SCHOOL BUS IS THE BIGGEST SELLER OF ALL TIME WITH NINE MILLION UNITS SOLD.

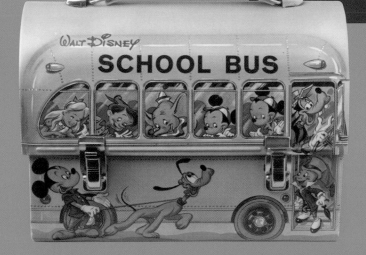

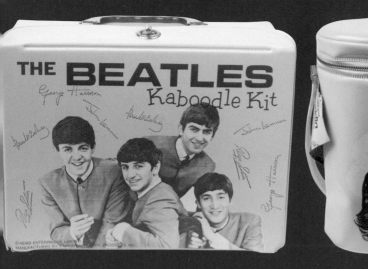

THE **BEATLES** Kaboodle Kit

CHARLIE'S ANGELS

and other movies of the era. It was a huge success. Subsequent domes featured other whimsical patterns, some of which used the shape of the boxes to brilliant effect (for example, the Disney School Bus box, which at nine million units was the biggest seller of all time). For a while, until the novelty faded, the domes were the coolest thing around.

The early 1960s brought yet another innovation, a design trend that was as short-lived as the dome: the vinyl lunchbox. Described later by an industry insider as "a piece of shower curtain plastic, heat-sealed over cardboard," the vinyls were usually colored pink and aimed at girls. Of these, the Barbie line sold very well, as did a Beatles box and a generic one known as the Bobby Soxer. Ultimately, however, shoddy designs and poor durability sunk the vinyl boxes pretty

quickly, and relatively few have survived to our time.

The lunchbox fad continued to prosper through the 1960s and 1970s, with the most popular sellers based on movies and TV shows. And, inevitably, lunchbox art itself worked its way into popular entertainment, creating a kind of self-referential loop. Richie Cunningham, the character from *Happy Days*, carried a Wild Bill Hickok box. Arnold Horshack on the sitcom *Welcome Back, Kotter* had a Planet of the Apes box. And later, even Brandon, the nice-guy transplant from the Midwest in *Beverly Hills, 90210*, would be seen with a Charlie's Angels box.

Despite the success of lunchboxes, it was a tough, cutthroat business. Competition for rights deals made them more and more expensive to produce, and the kids in the market

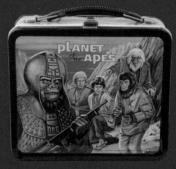

PLANET of the APES

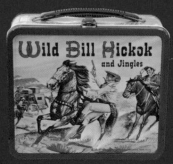

Wild Bill Hickok and Jingles

were unpredictable and fickle. By 1970, lunchboxes had had a good run, having sold about 120 million in two decades, but the boom couldn't last forever. Even from the first, the smaller companies began dropping out. ADCO stopped making lunchboxes in 1956; Universal in 1963; Ohio Arts in 1985.

Finally, in 1987 metal lunchboxes for kids disappeared. Blame it on the times: kids found athletic shoes, clothes, computer games, and other status symbols to beg their parents for. Blame it on manufacturers who started switching from metal to molded plastic to cut manufacturing costs. And blame it on crusading mothers and a group of pandering legislators who managed to ban metal lunchboxes by touting them as dangerous assault weapons in the schoolyard. The last metal lunchbox of the golden age of steel—fittingly depicting the ultimate tough guy, Rambo—was sold in 1987. Manufacturers switched entirely to cheap plastics with the designs molded in. Still, the decline continued when Aladdin announced that it was giving up the lunchbox business completely in 1998, leaving only American Thermos of the original big-time manufacturers, bloodied but standing tall.

Despite their "death," metal lunchboxes are slowly coming back—for adults, at least. Besides the feverish buying and selling on the collectors market, American Thermos

slipped a few metal boxes into its lunch lines a few years ago, and if you look around department stores and gift shops, you may encounter dozens of old nostalgia-lover's metal boxes in novelty shops and retro pop-culture stores. Some are replicas of classic designs of the past, others are new but with a retro look.

MAYBE THE VISIONARY ARTISTRY WILL COME BACK, PERHAPS IN METAL OR IN AN INSPIRED NEW VISION BASED ON PLASTIC MOLDING AS AN ART FORM. ONLY TIME WILL TELL WHETHER THE LUNCHBOX AS A FORM OF POPULAR ART WILL RISE AGAIN AMONG ELEMENTARY SCHOOL TRENDSETTERS. UNTIL THAT HAPPENS, THOUGH, ENJOY THE IMAGES IN THIS BOOK THAT CELEBRATE THEIR NOT-SO-DISTANT GLORY DAYS.

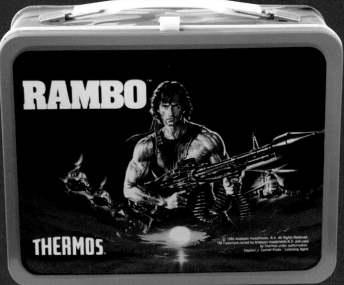

CULT TV

THE SHOWS THAT RERUN FOREVER IN OUR MINDS

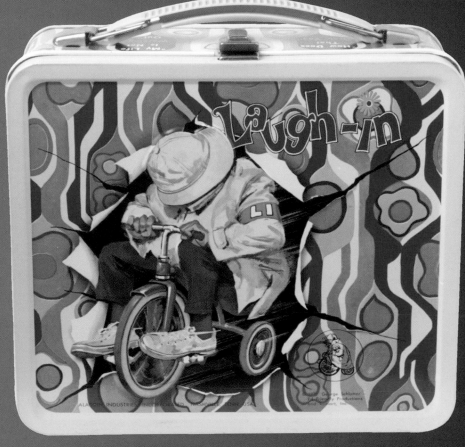

What makes for a cult television show? It isn't necessarily being long-lived, well-written, or well-acted. It's not just the amber glow it adopts among our childhood memories. These are relevant factors, but there's something else.

One clue lies in the originality of the show's cast of characters. *The Addams Family*, for example, had at least a half-dozen sui generis personalities, from Lurch to Thing. Another telltale sign is how convincingly it creates a world that's surreal and escapist and yet entirely credible on the screen—*H.R. Pufnstuf*, for example, or *Howdy Doody*. Sometimes it succeeds on the force and energy of a single personality—Soupy Sales, or the Fonz. Or it may remain indelible simply for being so outrageously bad, like *The Flying Nun* or *It's About Time*.

Whatever the case, memorable shows make for memorable lunchboxes, valued by serious collectors and whimsical buyers alike.

As the theme song put it, "It's about time/it's about space/about strange people in the strangest place." Sherwood Schwartz, the man who spawned the hit shows *Gilligan's Island* and *The Brady Bunch*, created this time-travel comedy about astronauts coping in prehistory. Midseason, they returned to modern-day New York City with caveman Gronk and his wife Shadd, played by comedy veterans Joe E. Ross and Imogene Coca, but nothing could save it from being a one-season flop.

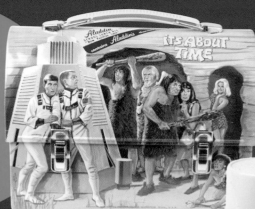

1.

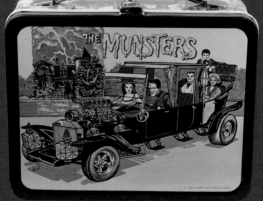

2.

1. *It's About Time*
Aladdin, 1967
$$

2. *The Munsters*
King Seeley, 1965
$$$$

3. *The Addams Family*
King Seeley, 1974
$$

4. *The Brady Brunch*
King Seeley, 1970
$$$$

The Addams Family, adorable freaks originally drawn by cartoonist Charles Addams for *The New Yorker*, attained cult status in the television series that ran from 1964 to 1966. Despite being far better than *The Munsters*, the show didn't get a lunchbox—this Addams Family box is from the cartoon series that ran for two seasons in the early 1970s. In it, Ted Cassidy (Lurch) and Jackie Coogan (Uncle Fester) reprised their roles vocally; other cast members included an eleven-year-old Jodie Foster as Pugsley.

3

4

The Howdy Doody lunchbox was hugely popular among child viewers of the hit TV show, so Universal became nervous when Judy Tyler (pictured right as Princess Summerfall Winterspring) left the series to star with Elvis in the more adult-oriented *Jailhouse Rock*. The company yanked this box off the market when Tyler was killed in an auto accident a few days before the film premiered in 1957.

1

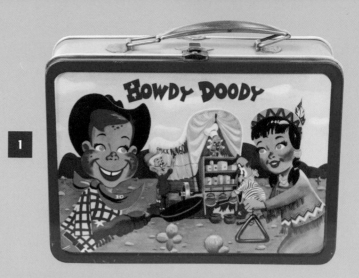

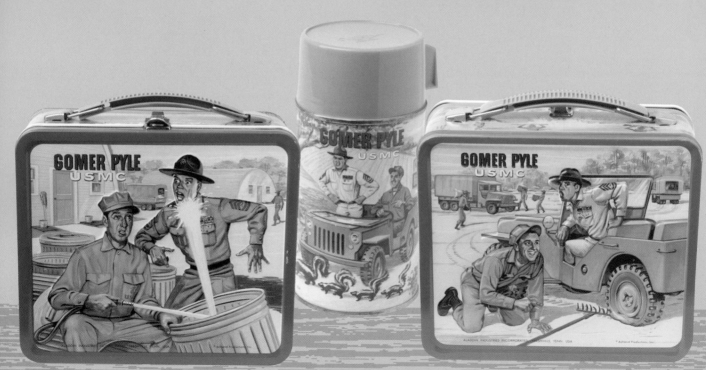

2

It's hard to imagine what they were thinking when they came out with this new TV series: just two decades after World War II, a show about fun and games inside a German prisoner of war camp, complete with comical Nazis. Aladdin came out with a clever dome designed to look like a Quonset hut, but the lunchbox became known as Aladdin's folly: When choosing to buy the rights to *Hogan's Heroes*, they passed on making Peanuts boxes, allowing their arch-rival King Seeley to make huge profits.

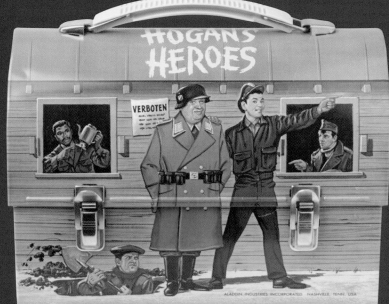

1. ***Howdy Doody***
 Universal, 1954
 $$$

2. ***Gomer Pyle, U.S.M.C.***
 Aladdin, 1966
 $$$

3. ***Hogan's Heroes***
 Aladdin, 1966
 $$$$

For centuries, members of the Krofft family were circus puppeteers in Europe, and Sid and Marty Krofft kept the family tradition alive in a Las Vegas puppet show. Through that, they were invited in the 1960s to create the life-size puppet rock 'n' roll monkeys for *The Banana Splits Adventure Hour*. This foray into television inspired a deluge of Krofft-produced Saturday morning shows from 1969 through the mid-1970s. *H.R. Pufnstuf* starred an orange dragon who was mayor of a town of talking trees, houses, and home furnishings. The Bugaloos were four singing bug teens who lived in a magic forest with their friend Sparky the Firefly. *Lidsville* featured a boy stuck in a land of talking hats; *Land of the Lost*, a family that got stuck in a land of dinosaurs; and the *Krofft Supershow* demonstrated that the Krofft brothers were stuck in a creative rut.

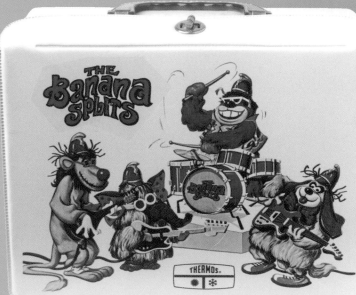

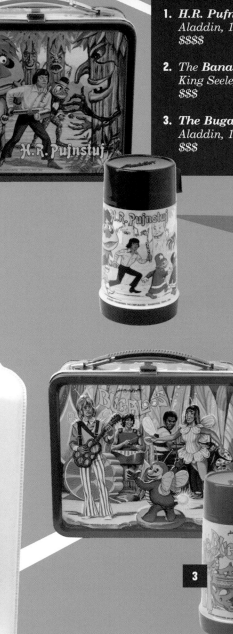

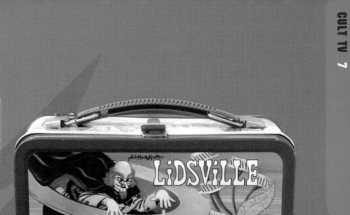

4. *Land of the Lost*
Aladdin, 1975
$$

5. *Lidsville*
Aladdin, 1971
$$$

6. *The Krofft Supershow*
Aladdin, 1976
$$

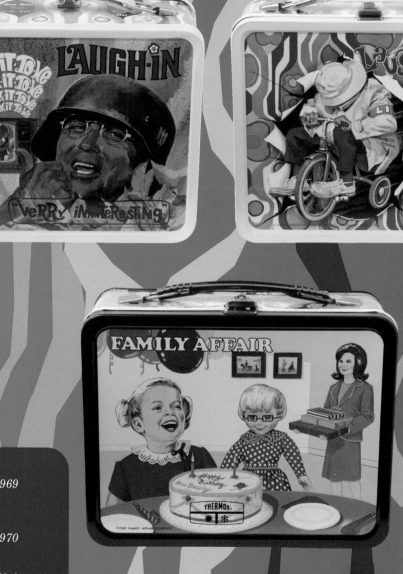

1. *Laugh-in*
 Aladdin, 1969
 $$$

2. *Laugh-in*
 Aladdin, 1970
 $$$

3. *Family Affair*
 King Seeley, 1969
 $$

"Hey kids, get those little green pieces of paper with pictures of George Washington, Benjamin Franklin, Lincoln, and Jefferson on them, send them to me, and I'll send you a postcard from Puerto Rico." This on-air joke got kid-show host Soupy Sales suspended for a week from his daily TV show. His trademark was getting a pie in the face, at least once per show—about nineteen thousand over the years. On the lunchbox, he's demonstrating a hit dance he invented called The Mouse.

4. *Soupy Sales*
Aladdin, 1965
$$$$

5. *Flipper*
King Seeley, 1966
$$$

After *Laugh-in* created a style of fast one-liners edited for a frenzied pace, other shows tried to copy the basic format. One, called *Turn-on*, was literally canceled halfway through the premier show. More happily, *Hee Haw*, hosted by country veterans Buck Owens and Roy Clark, enjoyed long-running syndicated success by mixing the comedy style of *Laugh-in* with a rural flavor and country music.

3. *The Waltons*
Aladdin, 1973
$$

4. *Little House on the Prairie*
King Seeley, 1978
$$

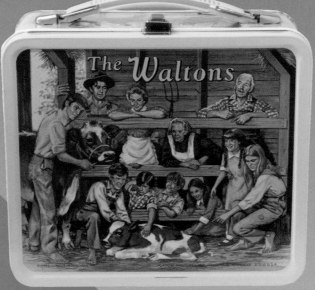

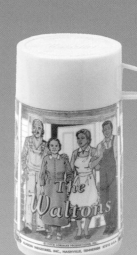

By the 1960s, it became clear that rural America as we knew it was quickly vanishing. The term *agribusiness*, coined by two Harvard economists in 1957, came into common usage as family farms were absorbed into corporate conglomerates. Yearning for a simpler time and place, viewers flocked to farm shows from the hilarity of *Hee Haw* and *The Beverly Hillbillies* to the sweet pioneer dramas of *The Waltons* and *Little House on the Prairie*.

The Dukes of Hazzard played on the appeal of a fast car named the General Lee, a bumbling sheriff, a sexy sister, and a host of other Southern stereotypes. When John Schneider and Tom Wopat, the original Duke boys, went on strike for more pay, the show replaced them with look-alikes playing their "cousins." The show's ratings quickly dive-bombed and the original Dukes were asked to return. Today, the "cousins" box is rarer and slightly more valuable to collectors.

1. ***The Dukes of Hazzard***
Aladdin, 1980
$

2. ***The Dukes of Hazzard (Duke cousins)***
Aladdin, 1983
$

3. *Happy Days*
King Seeley, 1977
$$

4. *The "Fonz"*
King Seeley, 1978
$$

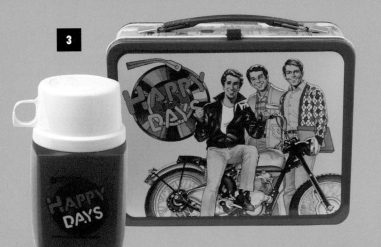

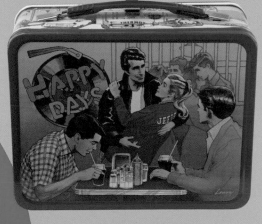

Note that these two lunchboxes are nearly alike, front, back, and sides—with one exception. During the first year of the show, the putative main characters, Richie Cunningham and Potsie Weber, were outshone by a character who was meant to be minor—Arthur "The Fonz" Fonzarelli. As a result, the same artwork appeared on the front with Richie and Potsie airbrushed out.

1

WELCOME BACK, KOTTER

WELCOME BACK, KOTTER

2

Mork & Mindy™

MORK & MINDY
©1979 Paramount Pictures, Inc.

Welcome Back, Kotter and *Mork & Mindy* were two archetypal 1970s sitcoms. They were also both launching pads for two actors who would go on to become major film stars: John Travolta *(above)* from *Kotter* and Robin Williams *(left)* from *Mork.*

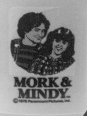

1. *Welcome Back, Kotter*
 Aladdin, 1977
 $

2. *Mork & Mindy*
 King Seeley, 1979
 $

In *Land of the Giants*, a kind of forerunner to *Honey, I Shrunk the Kids*, an American space crew ends up in a world of people just like us—except twenty times bigger! The little folks escaped giant pets, sadistic giant kids, a totalitarian government, and even circus owners who want to put them on display. On the back of this lunchbox, the little people battle a giant housecat with sticks and spears; on the front, they're menaced by what turns out to be a self-portrait of the box artist, Elmer Lehnhardt, as a giant man.

3. *Land of the Giants*
Aladdin, 1969
$$$

4. *The Flying Nun*
Aladdin, 1969
$$$

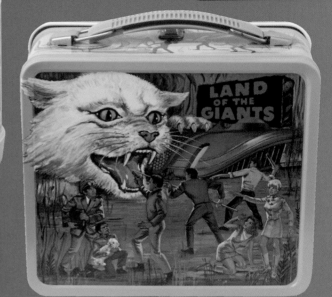

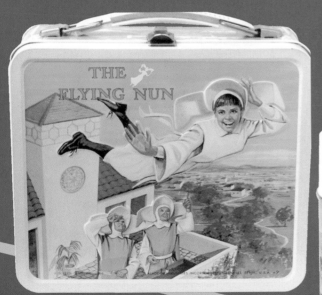

Rather implausibly, Sally Field starred as Sister Bertrille, a young nun whose coif, wimple, and coronet turned out to be accidentally aerodynamic in the brisk winds around her convent. As a result, she used her flying powers to do good all around the world. The back of the lunchbox shows Sister Bertrille on a collision course with a small plane.

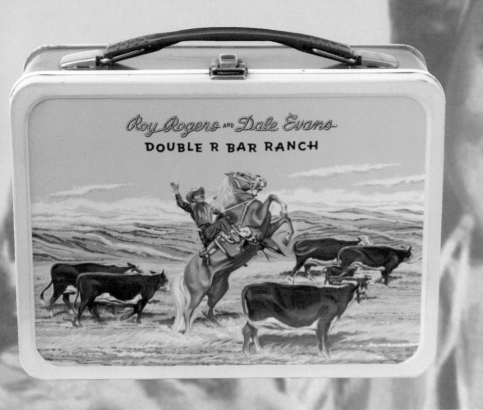

Roy Rogers AND Dale Evans
DOUBLE R BAR RANCH

For those who didn't live through the 1950s, it's hard to remember how thoroughly the Westerns took over the early days of American television. The good guys wore white, the bad guys wore black, and there was plenty of big action—bar fights, shootouts, horseback chase scenes—aptly suited for the small, black-and-white screens of the time.

As a result there were adult Westerns, kid Westerns, romantic Westerns, musical Westerns, mystery Westerns, comedy Westerns—a total of 120 different shows, by one count. Finally, by the early 1960s, the fad passed, leaving only the long-running television series *Gunsmoke*, as well as a handful of strange variations on the theme, such as

The Wild Wild West and *Cowboy in Africa*.

So it's fitting that Westerns played a pivotal role in lunchbox history. Not only was a Western theme (in the form of Hopalong Cassidy) the first shot fired in the golden age of lunchboxes, but another Western star—Roy Rogers—holds the record for having his image on the most lunchboxes.

The Hopalong Cassidy lunchbox started it all. In the boom years after World War II, manufacturers sold a lot of lunchboxes. Unfortunately, by 1949 sales were slumping. After all, lunchboxes were sturdy things that could last most of a kid's school career, so the market was pretty well saturated. The people at Aladdin decided to bring out flashy new models each year so that kids would want to throw out last year's perfectly good lunchbox and buy another. As an experiment, they slapped some decals of TV star cowboy Hopalong Cassidy onto some lunchboxes. It did the trick—Aladdin sold an unprecedented 600,000 Hoppy boxes the first year, most of them as replacements for lunchboxes that were perfectly serviceable (but boringly plain).

1. *Hopalong Cassidy (full lithograph)*
 Aladdin, 1954
 $$$

2. *Hopalong Cassidy*
 Aladdin, 1950
 $$$

4. *Wild Bill Hickok and Jingles*
Aladdin, 1955
$$

5. *Great Wild West*
Universal, 1959
$$$$

The Wild Bill Hickok box had a simulated "tooled leather" handle, which started a trend that manufacturers would latch on to for many of their Wild West boxes. The box supported the *Adventures of Wild Bill Hickok* TV show, starring Guy Madison. High-voiced Andy Devine played Jingles, a comic-relief sidekick who is also a master of disguises. Every show also featured Buckshot and Joker, their horses.

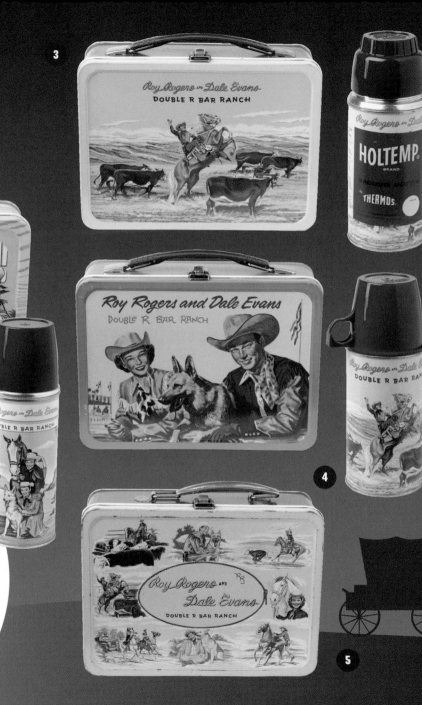

When rival TV cowboy Roy Rogers saw Hopalong Cassidy's lunchbox, he wanted to be on one, too. Rogers was unusual in that his TV cowboy character was happily married, so adding wife Dale Evans and horse Trigger appealed to girls, too. Featuring full-color lithography on all sides, American Thermos sold two and a half million of the Roy Rogers boxes in 1953 alone, and raised the bar for competitors whose decals now looked dingy and cheap in comparison. There were nine Roy Rogers metal box designs released between 1953 and 1961, as well as a few vinyl "saddlebags" for the young buckaroos.

1. ***Roy Rogers and Dale Evans***
 (side views)

2. ***Roy Rogers and Dale Evans***
 American Thermos, 1953
 $$

3. ***Roy Rogers and Dale Evans***
 (riding horse)
 American Thermos, 1955
 $$

4. ***Roy Rogers and Dale Evans***
 (with their dog, Bullet, a.k.a
 "red shirt" box)
 American Thermos, 1957
 $$$

5. ***Roy Rogers and Dale Evans***
 (eight scenes)
 American Thermos, 1955
 $$

6. ***Roy Rogers and Dale Evans***
 (Double R Bar Ranch)
 American Thermos, 1955
 $$

7. ***Roy Rogers and Dale Evans***
 Chow Wagon
 American Thermos, 1958
 $$$

8. ***Trigger***
 American
 Thermos, 1956
 $$$

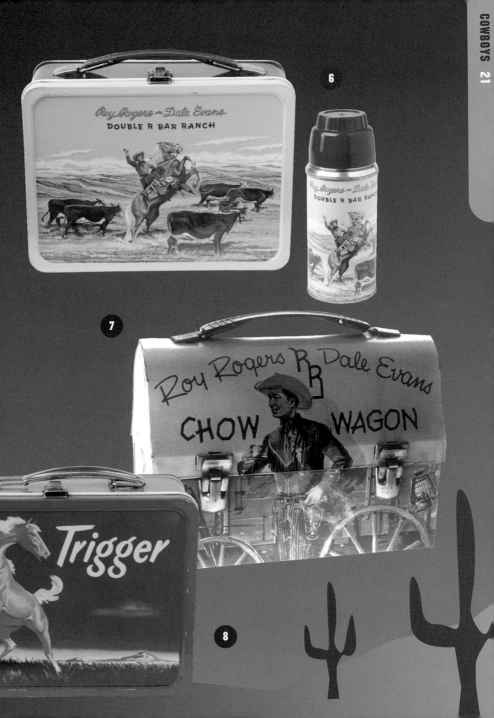

Gene Autry was America's best-loved singing movie cowboy of the 1940s. As his career on the big screen faded, he made a successful transition to television, starring in his own show for six years from 1950 to 1956. Ever the astute businessman, he saw the opportunity television presented and started a production company that made *Annie Oakley, Buffalo Bill Jr., Range Riders,* and other TV Westerns. In his lifetime, Autry also cut 635 records, including hits like *Back in the Saddle Again* and *Rudolph the Red-Nosed Reindeer.* He became one of *Forbes'* 400 richest Americans—and probably the only one who ever appeared on a lunchbox.

1. *Gene Autry*
Universal, 1954
$$$$

2. *The Lone Ranger*
Universal, 1954
$$$$

3. *The Legend of the Lone Ranger*
Aladdin, 1980
$

1

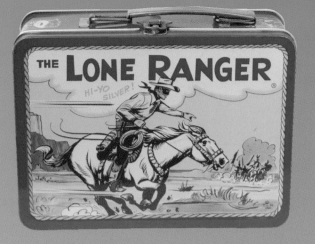

2

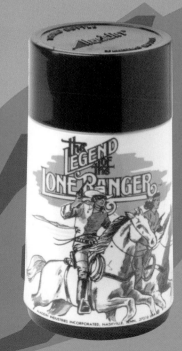

3

"Hi-yo Silver, and away!" *The Lone Ranger* was probably the most memorable of the Western shows, with elements that still resonate fifty years later: the masked rider, his faithful Indian companion, Tonto, the silver bullets, a white stallion named Silver, and a catchy intro and exit line for every show. *The Lone Ranger* had started as a radio program, but switched to television for an eight-year run beginning in 1949. Parents loved him because he used faultless grammar and never actually killed anybody (he was so good with a gun that he could shoot weapons out of the bad guys' hands). In 1980, the TV show inspired an uninspired movie remake, which also got its own lunchbox *(bottom left)*.

In *The Rifleman* Chuck Connors played a sheriff, a widower, and a dad of a boy whose age mirrored that of the show's target audience. The character's gimmick was that he never used a handgun for some reason, hence the name of the show. And what a rifleman he was—he could spin it on his finger and do a quick draw faster than any sidewindin', six-shootin' bad guy. Years later, *Cowboy in Africa* presented Connors as a champion rodeo rider hired by an English colonist to bring Western-riding-style methods to his game ranch in Africa. The show lasted only a year. It was Connors's last television series.

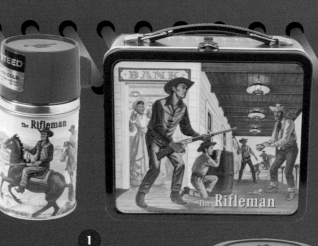

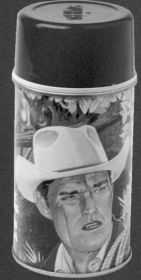

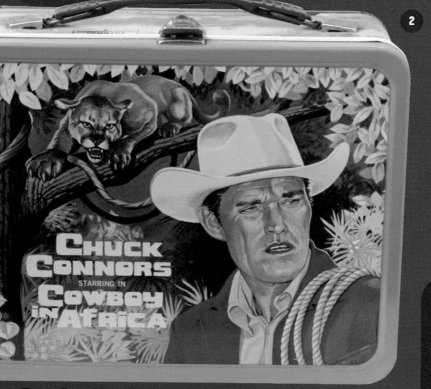

1. *The Rifleman*
 Aladdin, 1961
 $$$$

2. *Chuck Connors—*
 Cowboy in Africa
 King Seeley, 1968
 $$

The Guns of Will Sonnett was character actor Walter Brennan's last TV series. He played the title character, who was on a quest with grandson Jeff Sonnett to find Will's son (and Jeff's father), gunslinger James Sonnett. It took most of the first season to find him. One unusual feature of the series was that Brennan appeared at the end of each episode to sum up the moral of the story and to offer a cowboy prayer. The show was canceled after its second season.

3

4

3. *The Guns of Will Sonnett*
 King Seeley, 1968
 $$$

4. *Western box* (generic)
 American Thermos, 1963
 $$

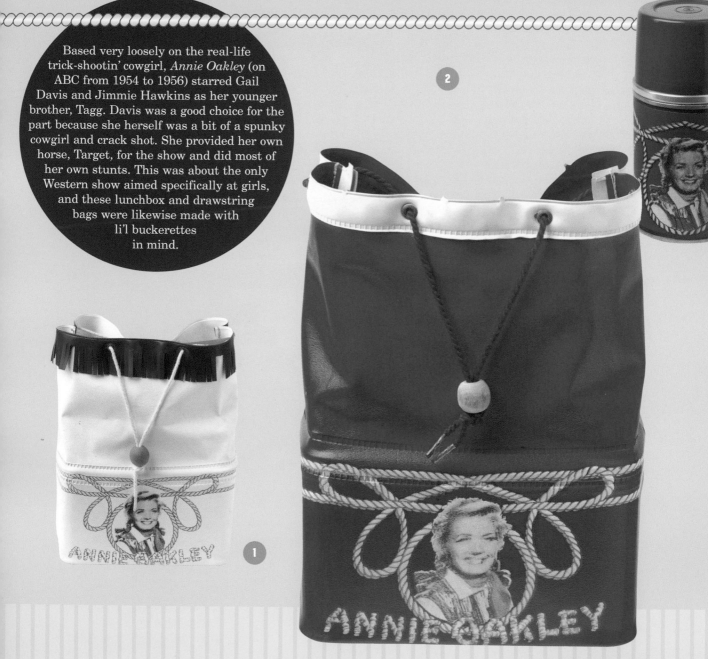

Based very loosely on the real-life trick-shootin' cowgirl, *Annie Oakley* (on ABC from 1954 to 1956) starred Gail Davis and Jimmie Hawkins as her younger brother, Tagg. Davis was a good choice for the part because she herself was a bit of a spunky cowgirl and crack shot. She provided her own horse, Target, for the show and did most of her own stunts. This was about the only Western show aimed specifically at girls, and these lunchbox and drawstring bags were likewise made with li'l buckerettes in mind.

ANNIE OAKLEY

ANNIE OAKLEY

2

1

1. **White Annie Oakley drawstring**
 Aladdin, 1950s
 $$$$$

2. **Red Annie Oakley drawstring**
 Aladdin, 1950s
 $$$$$

3. **Annie Oakley and Tagg**
 Aladdin, 1955
 $$$

4. **The Monroes**
 Aladdin, 1967
 $$

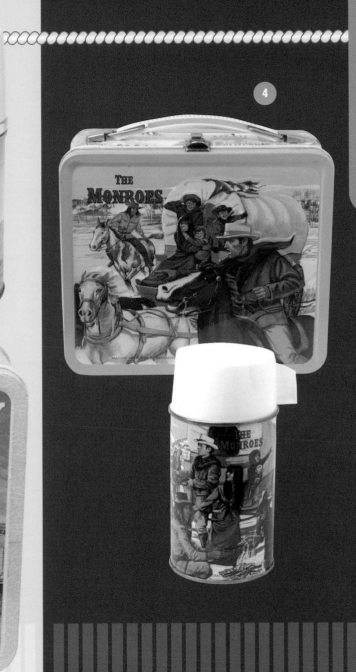

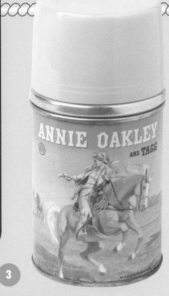

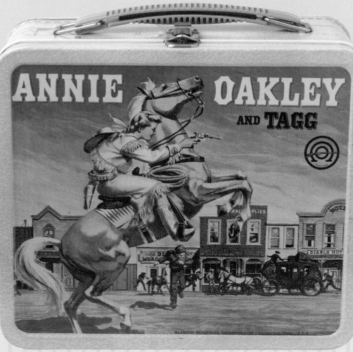

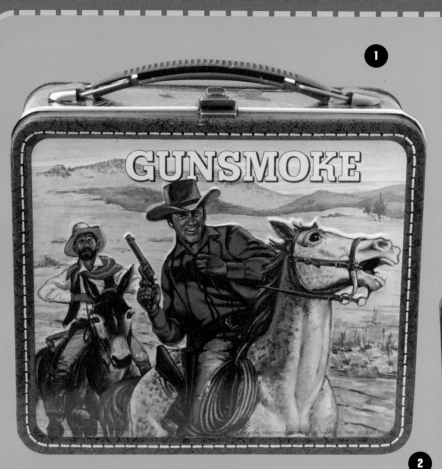

1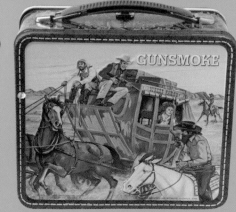

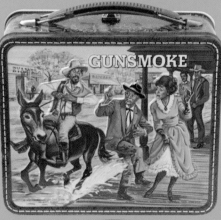

2

3

Aside from Sunday-morning public-affairs shows, *Gunsmoke* was the longest television series ever, running from 1955 to 1975, so you'd think they'd know how to spell the names and occupations of the major characters. But no, in 1959 Aladdin released a box with Marshal spelled with two l's. It was quickly recalled after five thousand boxes were shipped and reissued with the correct spelling. Because of its relative rarity the misspelled box is worth more to collectors than the corrected one. The "Splash" and "Stagecoach" scenes were each featured on the back of different versions of the Matt Dillon and Festus box.

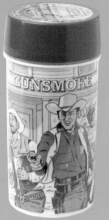
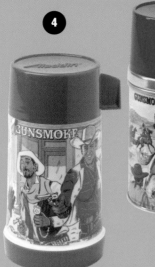
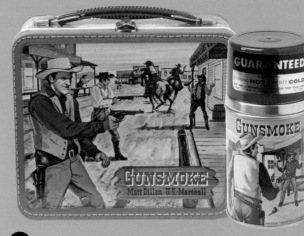

4

6

7

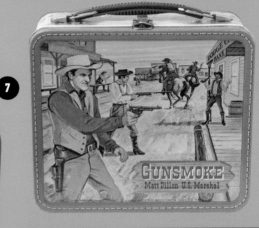

5

4. *Gunsmoke* (*thermoses*)
1972–73
$$

5. *Gunsmoke* (*red rim*)
Aladdin, 1962
$$$

6. *Gunsmoke* (*"Marshall" misspelling*)
Aladdin, 1959
$$$$

7. *Gunsmoke* (*"Marshal" spelling corrected*)
Aladdin, 1959
$$$

Bonanza's popularity from 1959 through 1973 made it a killer of shows scheduled against it. As reflected in the dwindling number of Cartwrights pictured on the boxes, Pernell Roberts left the show in 1965, leaving Ben and his two sons, Hoss and Little Joe (a young Michael Landon) without oldest brother Adam.

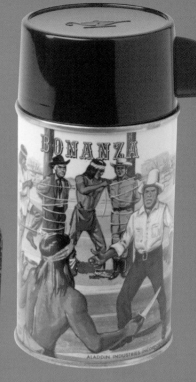

1

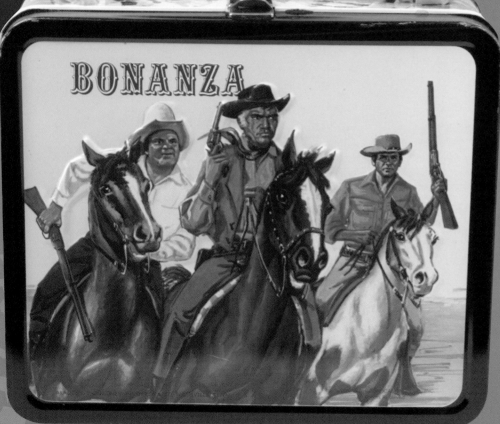

1. ***Bonanza***
 Aladdin, 1968
 $$$

2. ***Bonanza***
 Aladdin, 1963
 $$$

3. ***Bonanza***
 Aladdin, 1965
 $$

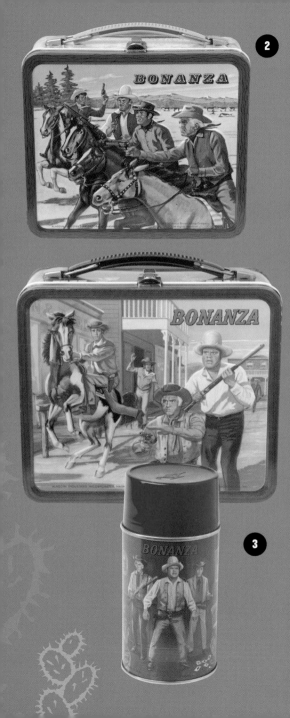

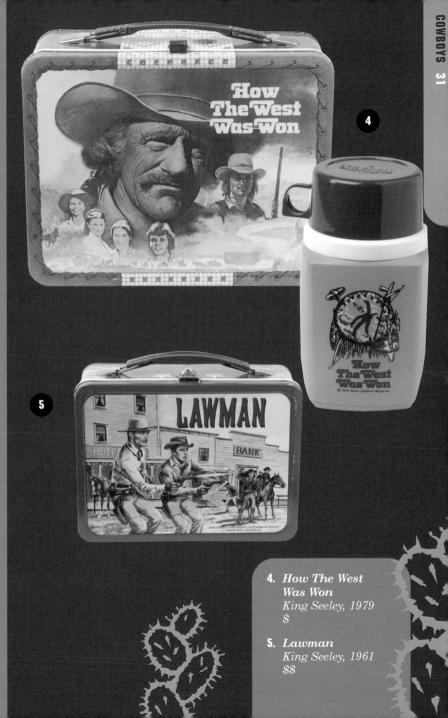

4. *How The West Was Won*
King Seeley, 1979
$

5. *Lawman*
King Seeley, 1961
$$

The novelty of the *Brave Eagle* TV series of the mid-1950s was that the main character was a Native American, and it was told from his point of view. Keith Larsen played the title character.

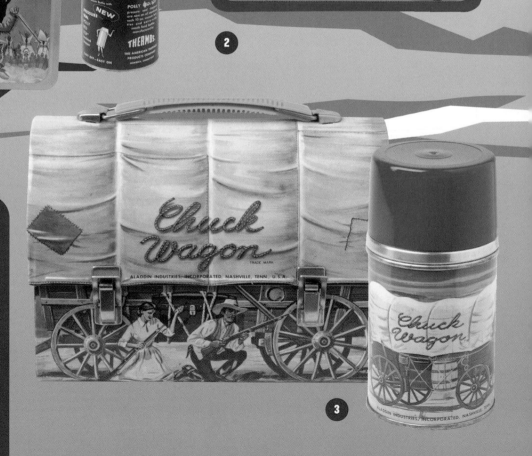

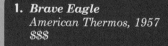

1. **Brave Eagle**
 American Thermos, 1957
 $$$

2. **Frontier Days**
 Ohio Arts, 1957
 $$

3. **Chuck Wagon** (generic)
 Aladdin, 1957
 $$

4. **Paladin: "Have Gun Will Travel"**
 Aladdin, 1960
 $$$

The dark, adult Western *Have Gun—Will Travel* about a thousand-dollar-per-job gunman was so popular among adults that—in the one-TV households of the time—kids watched too. The show's gimmick was that Paladin (Richard Boone) was a West Point graduate with sophisticated tastes who worked as a hired gun out of a San Francisco hotel. He was one of only a few good guys who wore black on the job. His business card read "Have Gun Will Travel," which became a much-imitated catchphrase. After the show ended in 1963, one of its writers, Gene Roddenberry, went on to create *Star Trek*.

PALADIN

HAVE GUN WILL TRAVEL

WIRE PALADIN
SAN FRANCISCO

ALADDIN INDUSTRIES INCORPORATED, NASHVILLE, TENN., U. S. A. ©1960 CBS INC.

HAVE GUN WILL TRAVEL

4

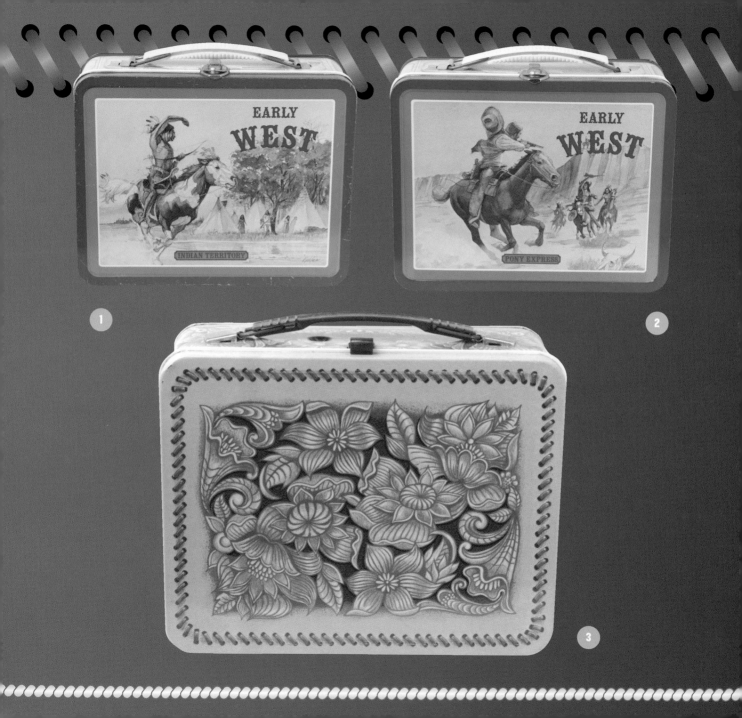

T*he Wild Wild West* was a strange hybrid: a Western with high-tech James Bond gadgetry. By order of President Ulysses S. Grant, James T. West and Artemus Gordon were two Secret Service agents working undercover in the Wild West immediately after the Civil War. They spent their time thwarting criminal masterminds who were a threat to the United States and the president himself. Their most powerful nemesis was Dr. Miguelito Loveless, a master designer of deadly squid robots, steam-powered giants, earthquake machines, shrinking potions, and worse.

3
CARTOONS & COMICS

DRAWING LUNCHBOX FANS TO THE CARTOONISTS' ART

Comic strips and cartoons have more in common than just being hand-drawn. The first theatrical cartoons were created by comic-strip artists. Before transparent cells made the job infinitely easier, cartoonist Winsor McCay drew the first cartoon ever, *Gertie the Dinosaur*, frame by frame—a labor-intensive project that took two years and more than ten thousand drawings. After its success in theaters, the Hearst newspapers bankrolled cartoons of their most popular comic strips as promotional stunts. Finally, in the era of Walt Disney and the Flescher Brothers, cartoonists became specialists, diverging from the comic-strip artists who became the pioneers of animation.

For all the talents of the artists who drew cartoons and comics, very few actually designed the lunchboxes based on their work. Even Charles M. Schulz—who never had an assistant for his comic strip—let an in-house artist draw his characters and design the box. Exceptions included Milton Caniff, who drew finely detailed Steve Canyon scenes for his box, and the Disney organization, which early on established themselves as the sole designers of their own lunchboxes.

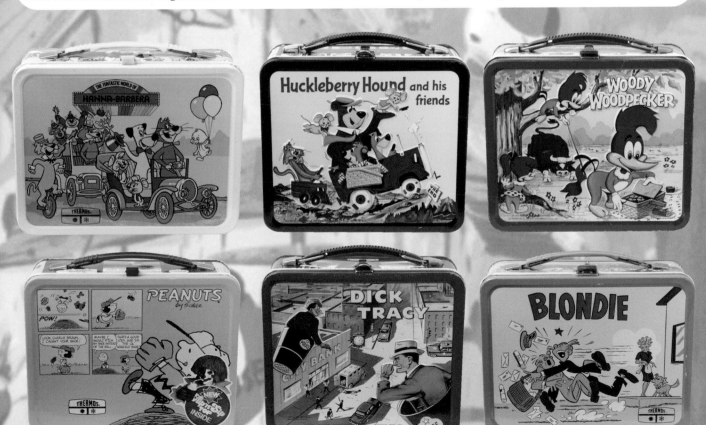

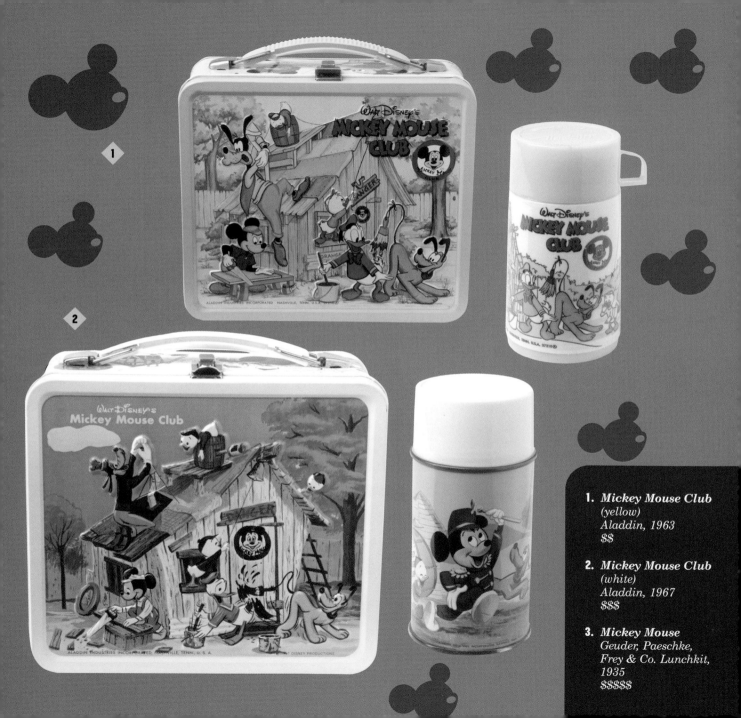

1. *Mickey Mouse Club*
 (yellow)
 Aladdin, 1963
 $$

2. *Mickey Mouse Club*
 (white)
 Aladdin, 1967
 $$$

3. *Mickey Mouse*
 Geuder, Paeschke,
 Frey & Co. Lunchkit,
 1935
 $$$$$

After Mickey Mouse made his debut in 1928 with *Steamboat Willie*, he became so popular that more than a million children joined the Mickey Mouse Club between 1929 and 1932. Mickey was first featured on this very limited edition 1935 lunch pail. Two decades later, Disney revived the Mickey Mouse Club name for a popular children's television series that aired on ABC from 1955 to 1959. The show was revived in the late 1980s and kick-started the careers of Mouseketeers Britney Spears, Justin Timberlake, and Christina Aguilera. The 1963 box came out after the first show had left the air, and was rereleased for after-school syndication.

3

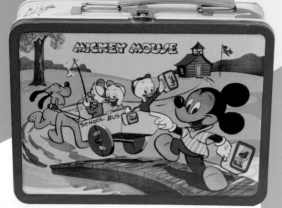

The Australian version of the Mickey Mouse lunchbox *(below)* had the same design as the American box of the same year, with Donald Duck featured on the back *(bottom, left),* but for some reason with wide-screen proportions.

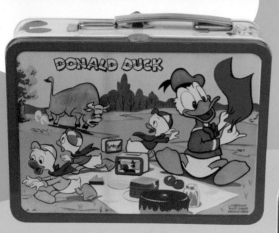

1. **Mickey Mouse**
 ADCO Liberty/Universal,
 1954
 $$$$$$

2. **Mickey Mouse**
 Australian (maker
 unknown), 1954
 $$$

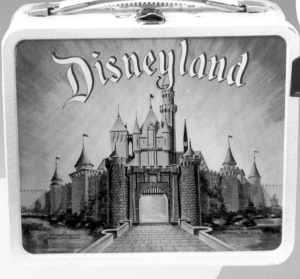

Disneyland, the amusement park financed by a cartoon mouse, opened in 1955. In the first years of "the happiest place on earth," Aladdin created a series of Disneyland lunchboxes. Some of the boxes and thermoses show rides that no longer exist—like the stagecoach ride—or have changed. For example, the Monorail lunchbox shows one of the two trains first created for the futuristic amusement park, "Red." (The other train was called "Blue." "Gold" came along a few years later.) Since then, the monorail has evolved with the times. It now looks less like the rockets and cars from the 1950s, and more like a present-day subway train.

3. **Disneyland** (white castle)
 Aladdin, 1957
 $$$

4. **Disneyland** (monorail)
 Aladdin, 1960
 $$$

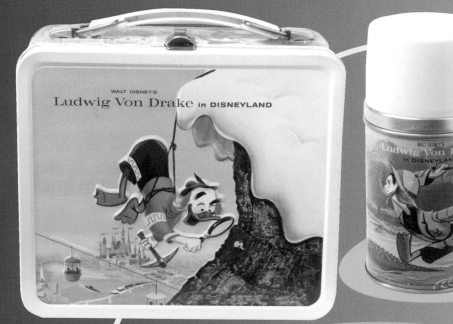

Ludwig von Drake was Donald Duck's scientific uncle by marriage (von Drake married Donald's aunt Matilda McDuck, who was Scrooge McDuck's sister). Born in Vienna, Von Drake appeared for the first time on an episode of *Walt Disney's Wonderful World of Color* on September 24, 1961. Here *(left)*, he is inspecting the native fauna of Disneyland's Matterhorn Mountain.

1. *Ludwig Von Drake in Disneyland*
 Aladdin, 1962
 $$$

2. *Tennessee Tuxedo*
 Ardee, early 1960s
 $$$$

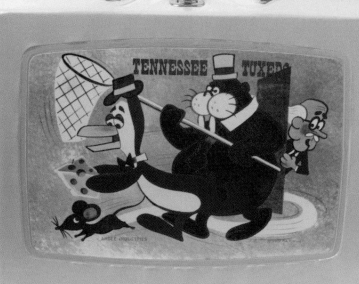

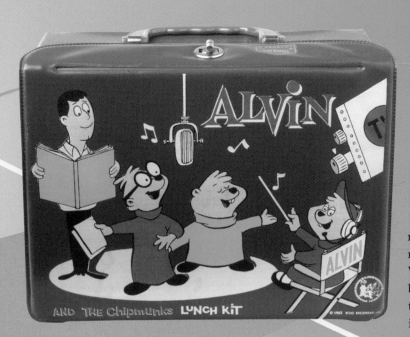

In the 1950s, novelty songwriter Ross Bagdasarian recorded a Christmas song starring a male trio speeded up to sound like mischievous little Chipmunks. His little rodents—named after Liberty Records execs Simon Waronker, Theodore Keep, and Alvin Bennett—became a huge hit. The record inspired a TV show that ran from 1961 to 1965, which in turn inspired this lunchbox *(left)*.

The nameless little ghost who didn't want to scare anybody first appeared in a cartoon short in 1945. In 1949, he became a comic book character and finally got a name, Casper, and a cast of supporting characters. Horse Nightmare, the Ghostly Trio, and Wendy, the Good Little Witch followed him into made-for-TV cartoons in 1963, which inspired this lunchbox *(right)*.

3. Alvin and the Chipmunks Lunch Kit
American Thermos, 1963
$$

4. Casper the Friendly Ghost
American Thermos, 1966
$$$

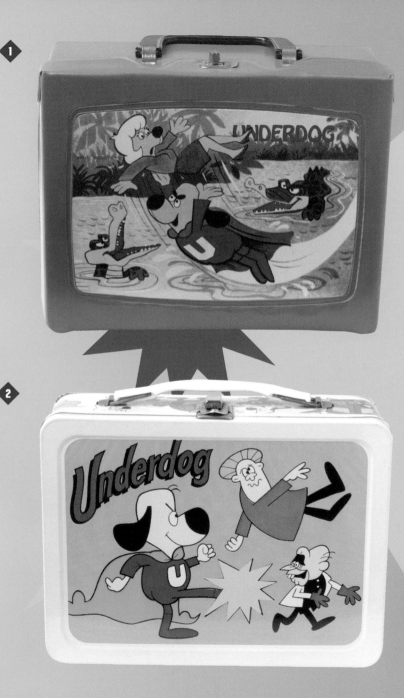

1

2

"It's only me . . . Underdog." With the voice of prototypical nerd Wally Cox, Underdog was the most humble superhero since Jesus. A parody of Superman, Underdog's incognito identity was that of a shoeshine boy. He even had his own Lois Lane–like unrequited love interest, reporter Sweet Polly Purebred, who ended up needing rescuing in just about every one of the 120 episodes filmed from 1964 to 1973.

1. *Underdog*
 Ardee, 1964
 $$$$

2. *Underdog*
 Universal, 1974
 $$$$$$

3. *Scooby Doo*
 King Seeley, 1973
 $$$

4. *Deputy Dawg*
 King Seeley, 1964
 $$$

Shaggy and Scooby-Doo get the Washington Irving treatment on this Headless Horseman lunchbox. The show was originally designed to be a cross between the 1950s teen comedy *The Many Loves of Dobie Gillis* and a 1940s radio drama called *I Love a Mystery,* but the concept shifted and a dog became the title character. He got his name from CBS exec Fred Silverman, who was inspired while listening to the "scooby doobie doo" lyrics of Frank Sinatra's *Strangers in the Night.* Scooby's voice came from Don Messick, who also played the Jetson's dog, Astro.

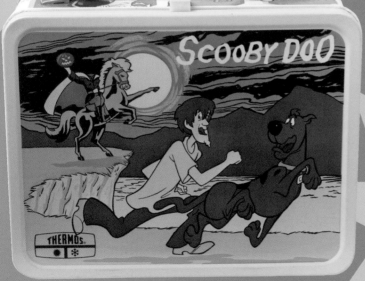

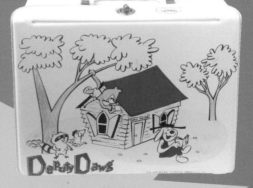

The New Hanna-Barbera Show was the uninspired title of a show syndicated to local stations by the Hanna-Barbera animation studio in 1962. It featured a three-cartoon package with Wally Gator, Touché Turtle, Lippy the Lion, and Hardy Har Har, a laughing hyena. In New York City, the cartoons were sandwiched into a show called *Cartoon Zoo* with a human zookeeper played by Milt Moss. Universal liked that name better and used it for its lunchbox, figuring it would play in the rest of the country, too. The Hanna-Barbera show lasted two years and fifty-one episodes; *Cartoon Zoo*, however, was canceled after just three months, owing to a dispute between Moss and station management.

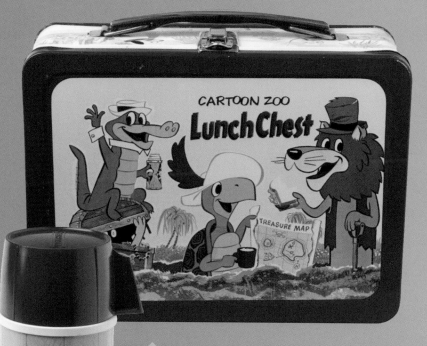

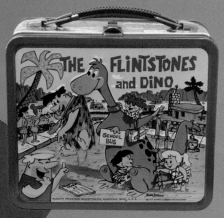

1. ***Cartoon Zoo Lunch Chest***
 Universal, 1962
 $$$

2. ***The Flintstones and Dino***
 Aladdin, 1962
 $$$

3. ***The Fantastic World of Hanna-Barbera***
 King Seeley, 1971
 $$

4. ***The Flintstones*** *(front and back)*
 Aladdin, 1964
 $$$

5. ***Pebbles and Bamm-Bamm***
 Aladdin, 1971
 $$

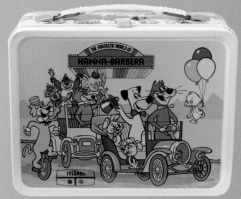

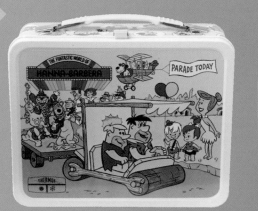

3

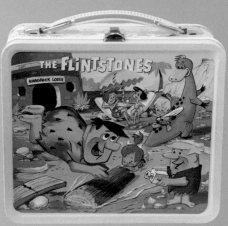

The Hanna-Barbera studios, creators of the hugely popular Stone Age family known as the Flintstones, pumped out an amazing number of shows with a formula that became known as "limited animation." They severely degraded the rich movement of theatrical cartoons into herky-jerky movements, using just a few drawings per second. They also set scenes with a lot of repetition so that artwork could be used over and over again, and limited movements so that only a small part of the frame had to be redrawn.

4

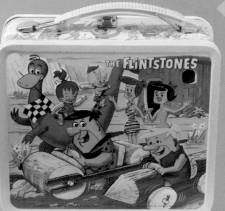

5

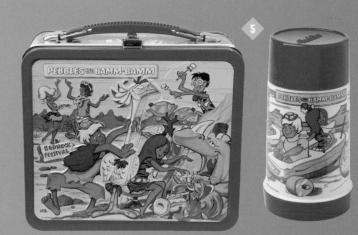

Beany and Cecil started in 1949 as a live puppet show on a Los Angeles TV station, featuring the voices of Stan Freberg and Daws Butler as a boy and his sea serpent friend. In 1959, the Emmy-winning show transferred its characters into cartoons for overseas theatrical release. They made their American debut three years later on ABC and ran until 1967.

Flexibility was a virtue of vinyl lunchboxes. The 1963 Beany and Cecil box *(below)* had a foldout trap door with a snap fastener on the side for easy access to the thermos. The brown vinyl box from 1962 *(right)* was supposed to be the same as the white-framed box *(above right)*, but the company accidentally printed it with the brown frame, so it's a rare and valuable oddity among collectors.

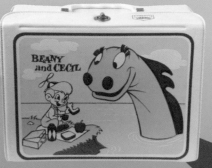

1.

1. *Beany and Cecil*
King Seeley, 1962
$$$

2. *Beany and Cecil*
King Seeley, 1962
$$$$

3. *Beany and Cecil*
King Seeley, 1963
$$$$

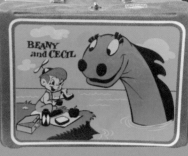

2.

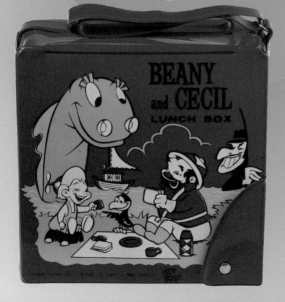

3.

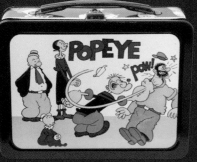

4

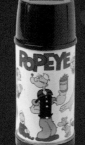

5

Popeye was one of the few characters who successfully made the leap from the newspapers to cartoons. He appeared as an incidental character in a strip called "Thimble Theater," but Popeye was so memorable that he upstaged the stars, Olive Oyl, Caster Oyl, and Ham Gravy, and slowly took over the strip. In 1933, he first appeared in a cartoon for movie theaters. By 1957, when he got his own TV show, Popeye had appeared in 228 cartoons.

6

4. *Popeye*
Universal, 1962
$$$

5. *Popeye*
American Thermos, 1964
$$

6. *Popeye*
Aladdin, 1980
$

In commercial-inspired cartoons, *Linus the Lionhearted* was a lowlight: a show produced by General Foods featuring characters who had appeared as shills for Post cereals, including the "can't get enough of that Sugar Crisp" bear, Sugar Bear. Still, it featured an all-star vocal cast that included Carl Reiner, Ruth Buzzi, Jerry Stiller, and Ann Meara.

1

2

History hasn't been kind to Hector Heathcote—he is pretty much forgotten nowadays. It's ironic because history is where he spent all his cartoon time. The inventor of a time machine, Heathcote traveled to the days of the War of Independence to help Paul Revere, Franklin, Jefferson, Washington, and the revolutionary boys throw off the yoke of British rule. *The Hector Heathcote Show*—which debuted on October 5, 1963, and ran for two years—also featured cartoons of Hashimoto-San (a martial arts mouse) and Silly Sidney (a neurotic elephant).

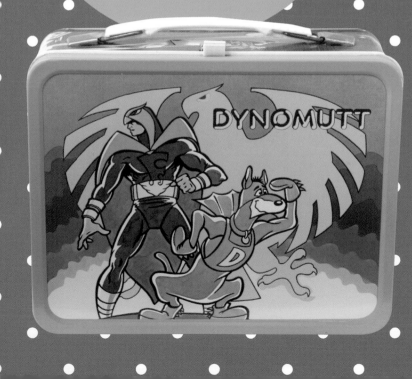

1. *Woody Woodpecker*
Aladdin, 1972
$$

2. *Linus! the Lion Hearted*
Aladdin, 1965
$$$

3. *Hector Heathcote*
Aladdin, 1964
$$$

4. *Dynomutt*
King Seeley, 1977
$

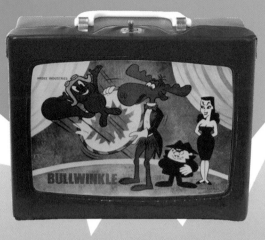

1

2

Rocky was short for Rocket; Bullwinkle got his name from Bullwinkel Ford, a car dealership in Berkeley, California, near Jay Ward's house when he was a real estate agent instead of cartoon genius. *Rocky and His Friends* was the original name for the show, and although Rocky was the smart one, Bullwinkle got all the best lines and quickly upstaged the nominal star, and it was soon changed to *The Bullwinkle Show*. Dimwitted Dudley Do-Right was the star of one of the show's more popular spin-offs, and he got his own lunchbox in 1962.

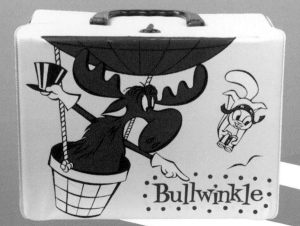

3

4

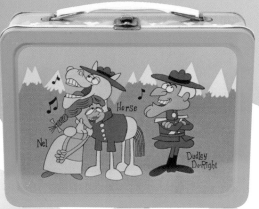

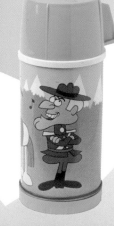

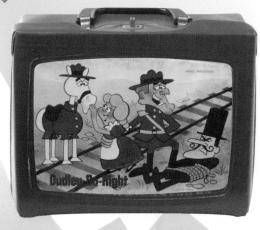

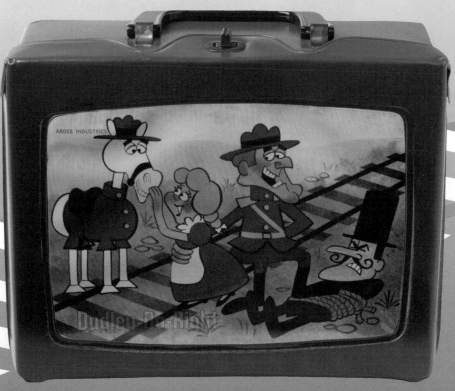

1. **Bullwinkle and Rocky** *(Universal/Okay Industries, 1962)*
$$$$$$

2. **Bullwinkle** *(prototype)* *Ardee, 1962*
$$$$

3. **Bullwinkle** *(hot-air balloon)* *King Seeley, 1962*
$$$

4. **Bullwinkle** *(blue)* *King Seeley, 1963*
$$$

5. **Dudley Do-Right** *(blue)* *Universal, 1962*
$$$$$$

6. **Dudley Do-Right** *(brown)* *Ardee, early 1960s*
$$$$$

7. **Dudley Do-Right** *(prototype)* *Ardee, early 1960s*
$$$$

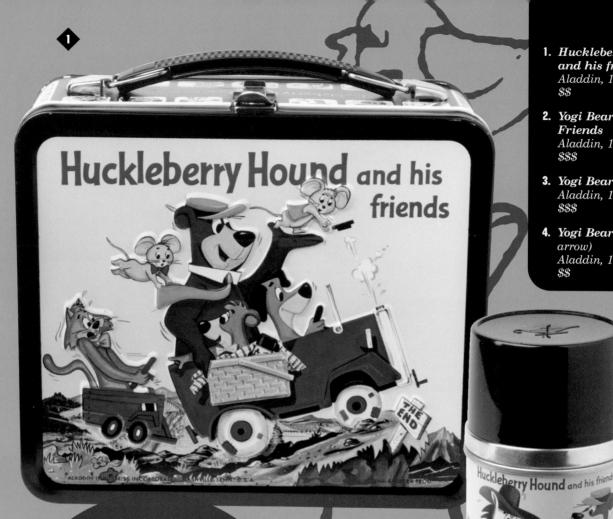

1

1. *Huckleberry Hound and his friends*
 Aladdin, 1961
 $$

2. *Yogi Bear and Friends*
 Aladdin, 1964
 $$$

3. *Yogi Bear (vinyl)*
 Aladdin, 1961
 $$$

4. *Yogi Bear (with arrow)*
 Aladdin, 1974
 $$

Huckleberry Hound and his friends

In 1958, *The Huckleberry Hound Show* became the first weekly half-hour show that consisted solely of animation. Besides the slow-drawling Huckleberry, there were the two mice, Trixie and Dixie, who tortured Mr. Jinx the cat, and the picnic basket–stealing Yogi Bear. The bear quickly upstaged the hound. At the last minute in 1961, Yogi was spun off into his own show, which is why the same box design was released under two names that year (*above and opposite top*).

Huckleberry Hound and his friends

TUG-O-WAR CONTEST

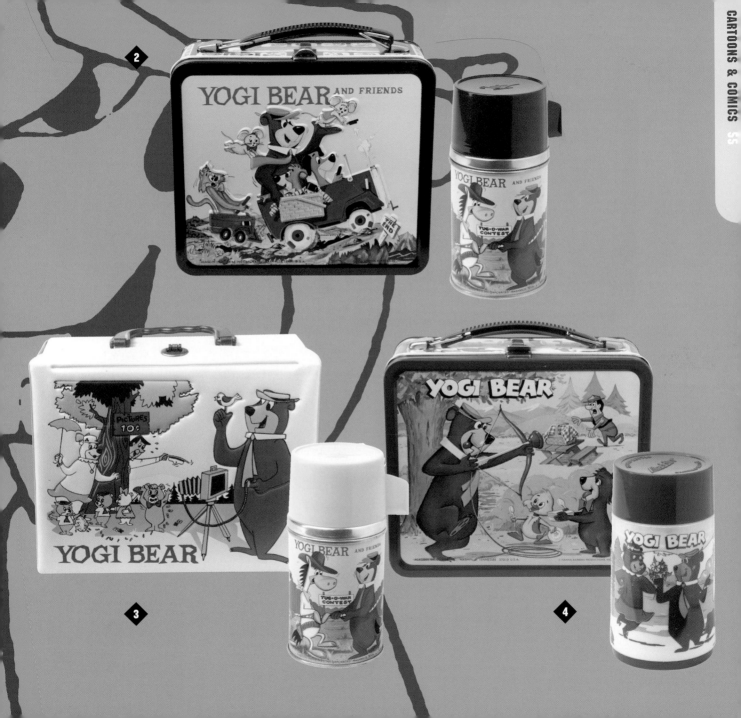

1

2

3

From the 1930s and onward, the Warner Bros. cartoonists perfected the short-form cartoon and such memorable characters as Bugs Bunny, Elmer Fudd, the Road Runner, and Yosemite Sam. Lovingly animated with a manic surreality aimed at an adult funny bone, many kids had the good taste to love them, too. While best appreciated on the large screen, the cartoons made a successful transition to the TV screen, as commemorated on this 1959 lunchbox *(left)*.

THE ROAD RUNNER

THERMOS.

Beep Beep

YOSEMITE SAM

THE ROAD RUNNER

THERMOS

1. **Loony Tunes**
 American Thermos, 1959
 $$$

2. **The Road Runner**
 King Seeley, 1970
 $$

3. **Yosemite Sam**
 King Seeley, 1971
 $$$

4. **Smurfs**
 King Seeley, 1983
 $$

5. **Atom Ant**
 King Seeley, 1966
 $$

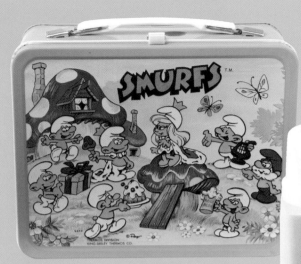

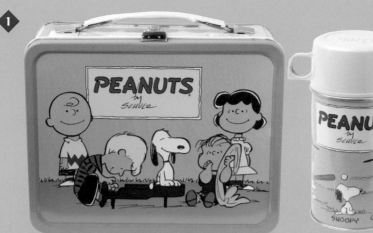

C harles M. Schulz started "Peanuts" as an understated commentary on the foibles of human behavior in the early 1950s, but by the mid-1960s the popularity of the strip made it less a comic strip and more a marketing powerhouse. Schulz was so impressed by the rendering of his characters on the first lunchbox in 1966, that he hired the artist, Nick LoBianco, to ghost design all of the images on subsequent Peanuts merchandise. But none of them are worth much money to collectors because of their wide visibility.

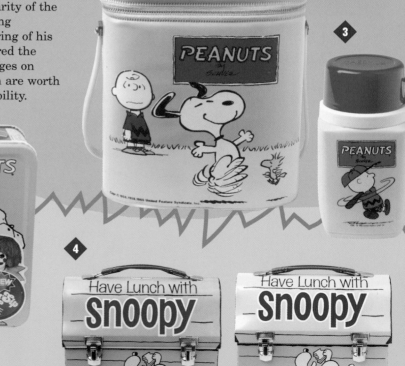

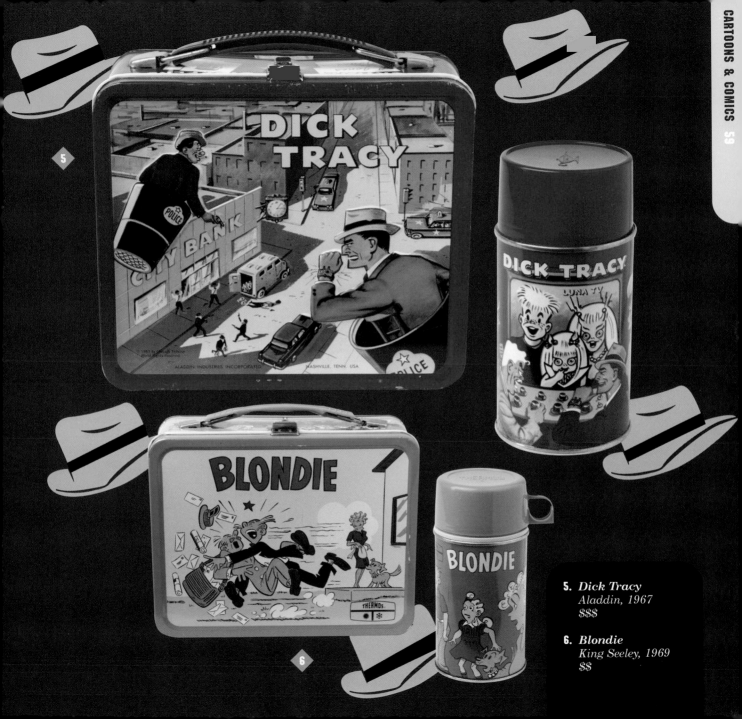

5. **Dick Tracy**
 Aladdin, 1967
 $$$

6. **Blondie**
 King Seeley, 1969
 $$

4

WHEELS

SATISFYING A KID'S NEED FOR SPEED

The advent of the wheel was a huge step for humankind, giving us the power to haul, tote, and travel. Then and now, guys with a fast set of wheels, whether a Roman chariot or a sports car, hoped to win respect, and, most important, the love of the chicks.

From the late 1960s through the '70s, wheels became a recurring theme on lunchboxes, inspired by a booming American car culture. Movies like *Smokey and the Bandit* created a national love affair with fast car chases, as well as the lovable rascals who gunned their supercharged engines and broke all speed limits. In the early 1980s, TV shows like *The Dukes of Hazzard* and *Knight Rider* capitalized on the automobile as a symbol of high-octane power, and made the muscle car an ally in the battle against evil.

Sensing the marketing potential of all things vehicular, Hot Wheels and NASCAR were quick to jump on the promotion racetrack. The major lunchbox makers understood a kid's need for speed, even if only in his dreams. Best of all, most kids' fantasies about burning rubber transcended brand names, which meant makers could sell generic boxes without sharing profits with licensees —something *they* could get their engines revved about.

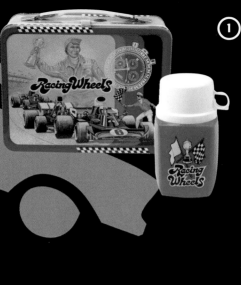

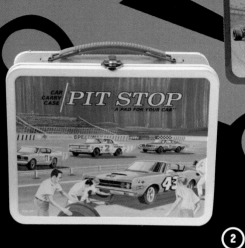

Pit Stop was more than a lunchbox: Inside, it sported a mini–car holder for your Hot Wheels, Tonka, and Matchbox cars. Unfortunately for collectors, most of the few Pit Stop boxes in existence today are missing their car holders. Parents didn't mind Jimmy having a race car lunchbox, it seems, but believing it was best used for sandwiches, not toy cars, they yanked out the insert.

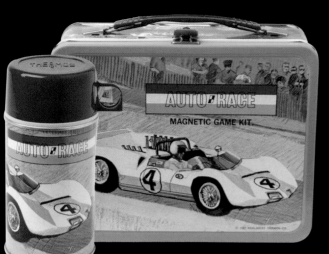

③

④

The *Knight Rider* TV show starred David Hasselhoff as secret crime fighter Michael Knight. However, the real star of the show was his car, K.I.T.T., a souped-up Trans-Am with artificial intelligence and a human voice. Although the series became a huge hit, it began as a gag. For years, NBC executive Brandon Tartikoff joked that he would one day make a hit series with a car that could talk, so that his leading man wouldn't have to be much of an actor.

Somewhere along the line, his joke became a reality and the series ran from 1982 to 1986. The lunchbox was designed by Gene Lemery, an artist whose work is prized by collectors.

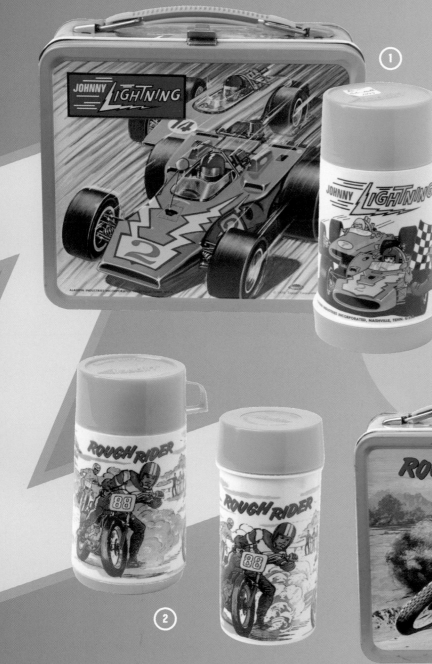

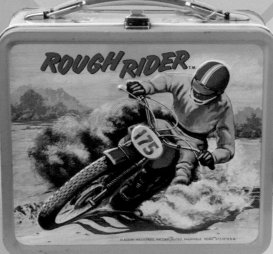

J ohnny Lightning was a brand of cars much like Hot Wheels or Matchbox, produced by the Topper Company from 1969 to 1971. In 1970, the year before both the cars and their manufacturer faded into obscurity, pro racer Al Unser drove a "Johnny Lightning" car in the Indianapolis 500 and won. Aladdin rode the subsequent wave of publicity with this lunchbox *(left)*.

Motocross originated in Europe shortly after World War II, but didn't hit the United States in any significant way until the late 1960s. Owing to weekend coverage by ABC's *Wide World of Sports*, motocross became all the rage in the 1970s. This Rough Rider box (with two thermoses with different size cups) glorifies motocross riders as happy as "hogs" in mud.

1. **Johnny Lightning**
 Aladdin, 1970
 $

2. **Rough Rider**
 Aladdin, 1973
 $

3. **Track king**
 Universal, 1975
 $$$

4. **DragStrip**
 Aladdin, 1975
 $

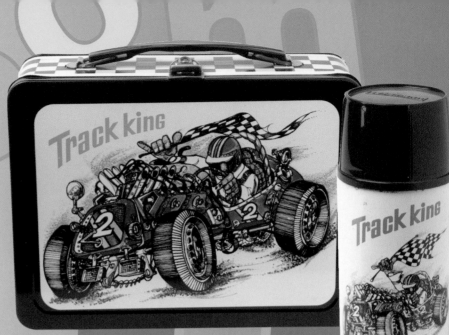

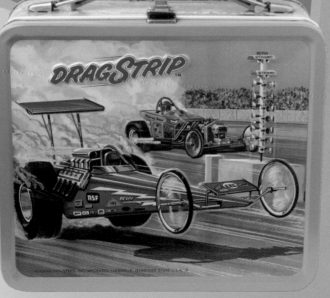

5

SPORTS
FROM IDIOT BOX TO LUNCHBOX

In the mid–twentieth century, television played a crucial part in bringing sports deeper into the popular culture . . . and eventually onto the nation's lunchboxes.

It took some time to get it right. Broadcasting history tells us that the first televised sporting event was a baseball game between Ushigome and Awazi Shichiku Higher Elementary Schools on the Tzuka (Japan) Baseball Grounds. The experimental broadcast took place on September 27, 1931. A few years later, American broadcasters took their cameras out to the field to see how well television could cover sports. The answer, with the tiny TV screens and bulky cameras of the day, was "not very well."

Of all sports, boxing, with its compact arenas, made the easiest transition to the small screen. For early broadcasts, the arena became even smaller; boxing rings were shrunk so the fighters could stay in camera range. The first televised matches were lit to blinding levels.

Two decades later, the kinks had been worked out and sports broadcasts became a staple of American television. Although Americans had been avid followers of local teams before radio and television, it took the mass media (and helpful politicians willing to grant monopoly powers) to create a nation of couch potatoes cheering, cursing, and shouting advice to their favorite teams from their sofas. The "tator tots" who cheered along with their dads wanted any merch the sports establishment had to offer, so it's no surprise that sports lunchboxes scored a touchdown in the 1960s and beyond.

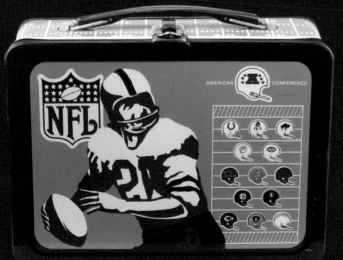

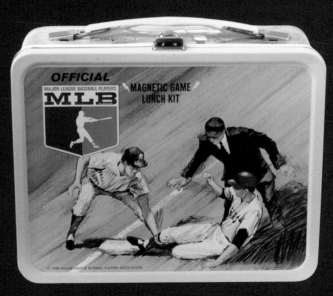

Credit McGill University in Quebec, Canada, for its role in creating American football. In 1874, its rugby team arranged to play some exhibition games at Harvard University. The Harvard jocks, turned on by this new sport with an egg-shaped ball, spread it throughout the Ivy League. Canadian and American football evolved separately into similar games with some quirky differences—the Canadian field, for example, has two fifty-yard lines instead of one, making it 110 yards long.

1

2

Perhaps as a consolation prize for their mediocre 1970 season (six wins, eight losses), the Washington Redskins got their own lunchbox *(left)*.

1. *Canadian Football*
 Canada, General Steelware, 1960s
 $$$

2. *Washington Redskins*
 Universal, 1970
 $$

The National Football League was racially integrated in 1946 when the Los Angeles Rams signed Kenny Washington, ending a thirteen-year ban on black players. However, you wouldn't know it from the lily-white players adorning both sides of this lunchbox *(below, right)*, released during the height of the civil rights era.

In 1962, President John Kennedy signed an exemption that allowed a monopoly, the National Football League, to sell exclusive broadcasting rights to the highest TV and radio network bidder. Realizing that great amounts of money could be made outside the stadium, the NFL created a licensing group to market logos, teams, and lunchboxes *(below, left)*.

3. NFL
Universal, 1962
$$

4. NFL Quarterback
Aladdin, 1964
$$

1. **Boating**
 American Thermos, 1959
 $

2. **Pelé**
 King Seeley, 1975
 $

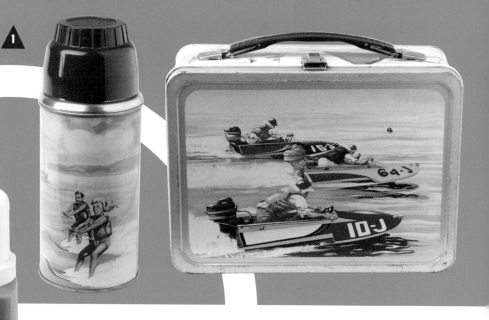

Born Edson Arantes do Nascimento, Brazilian soccer star Pelé was one of the most beloved sports figures in the world. In 1975, he came out of retirement to play for the New York Cosmos, leading them to a North American championship and sparking an American interest in soccer for the first time. This lunchbox *(right)* remains one of a very few of the 1960s to feature a black person.

3. *Canadian Hockey*
General Steelware, 1960s
$$$

4. *National Hockey League*
Universal, 1970
$$$

5. *Boston Bruins*
Universal, 1973
$$$

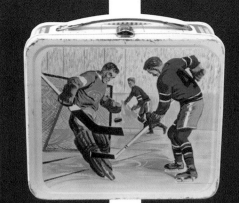

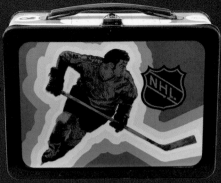

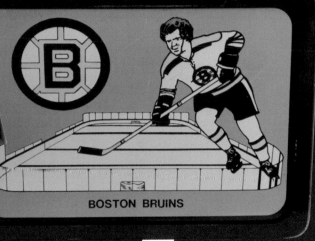

BOSTON BRUINS

S core another one for Canada. In the mid-1850s, a bored British soldier stationed in Quebec came up with the idea of playing a goal-and-stick game on ice skates. The rules were refined at McGill University into what we today call hockey (from the French word for a shepherd's crook, *hoquet*).

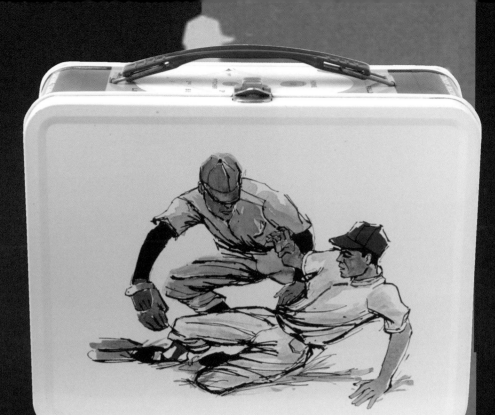

DOUBLE STEAL

DOUBLE STEAL

Before the American baseball leagues expanded into Canadian cities, sports fans from Montreal to Edmonton tended to follow U.S. teams. As a result, this generic Canadian baseball lunchbox *(above)* is rarer, and therefore more valuable, than its American counterparts.

1

The baseball leagues had to play catchup at the marketing blitz pioneered by the NFL, and consequently there are fewer brand-name baseball lunchboxes. This particular box *(right)* is unusual in that it came with a magnetic baseball game on the back.

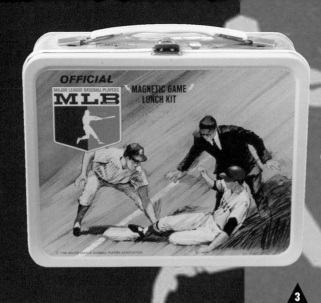

OFFICIAL
MAJOR LEAGUE BASEBALL PLAYERS
MLB
MAGNETIC GAME LUNCH KIT

© 1956 MAJOR LEAGUE BASEBALL PLAYERS ASSOCIATION

3

MLB

SPORTS AFIELD

2

Can't make up your mind about which sport is your favorite? This box featured baseball, football, hockey, basketball (on the back), and tennis (on the side). Generic boxes like this were a specialty of Ohio Arts, a company that favored cheaply rendered, royalty-free designs.

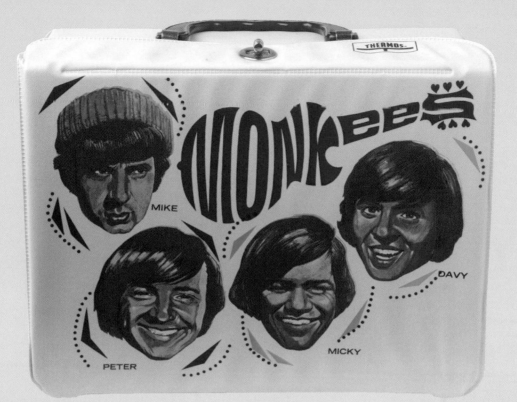

Had rock 'n' roll been more socially acceptable in the 1950s, and lunchbox makers more marketing savvy, preteen cool cats would have been packing their PB&J sandwiches in boxes sporting images of Elvis, Ricky Nelson, and Fabian. Instead, America's youth had to wait nearly a decade for the music revolution to make its mark on the lunchbox.

The Beatles came first. As America got infected with Beatlemania, the Fab Four's first manager, Brian Epstein, presided over a licensing frenzy that brought the Beatles imprint to scores of products. Legitimate lunchbox makers, however, were a little slow to pin down the rights, setting the stage for bootleg manufacturers to put out unauthorized knockoffs. (One reportedly built a successful business manufacturing cheap boxes in a Bronx, New York, loft; see page 81.)

Pop music of the 1960s is celebrated for its experimentation, but one innovation still lingers like a bad flashback: the boy band. After the Beatles grew up and became all psychedelic and experimental, a second generation of largely prefabricated groups entered to fill the void. The Monkees came first, four young men selected by producers to simulate a rock band, air-playing and lip-synching on TV to prerecorded tracks made without their musical input. Other groups—the Archies, the Osmond Brothers, and the Partridge Family—followed, offering cute, wholesome, nonthreatening faces in opposition to 1960s counterculture.

Heartthrob David Cassidy and his stepmother, Shirley Jones, headed the Partridge Family, a made-for-TV-sitcom musical confection based on a real-life group, the Cowsills. In fact, the show's writers briefly considered featuring this family of real singers on the show, but decided instead to go with actors who could pretend to sing. When the producers discovered that Cassidy had a voice, they let him handle some of the solos, speeding up his voice a few notches to make him sound younger.

★ 1

1. **The Partridge Family**
 King Seeley, 1971
 $$

2. **Go Go**
 Aladdin, 1966
 $$

3. **Pink Lady**
 *(lunchbox and packaging
 manufacturer unknown),
 Japanese, 1978*
 $$$$

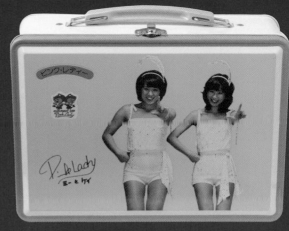

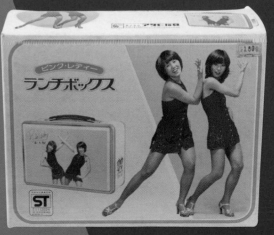

The Pink Lady lunchboxes *(right)* celebrated the pop group's short-lived heyday in Japan. After a two-year splash in their own country, the cute duo traveled to America in 1980 to cohost a TV show, *Pink Lady... and Jeff.* Alas, the girls couldn't speak a word of English and had to learn their lines phonetically, which may explain why the show tanked.

As the Beatles moved beyond pop superstardom, the Monkees—modeled after the Fab Four in *A Hard Day's Night*—jumped in to take their place in the cute-boy universe. They were successful beyond all expectations during their TV show's two-year run, racking up a record four number one albums in one year (1967). Davy Jones was the cute one; Peter Tork, the wacky one; Mike Nesmith, the smart, brooding one; and Micky Dolenz, the best singer. In addition to designing this box, artist Nick LoBianco also created the Monkees' guitar logo.

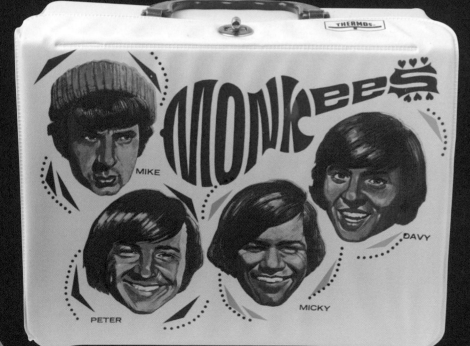

1. Monkees
King Seeley, 1967
$$$$

2. *The Archies*
Aladdin, 1969
$$$

3. *KISS*
King Seeley, 1977
$$$

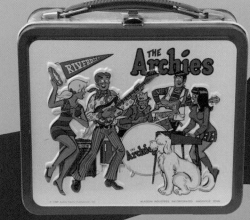

2

The Archies, based on "Archie" comics, were cartoon characters pretending to be a band. Betty and Veronica's voices were provided by studio singers Toni Wine and Donna Marie; the voices of Archie, Jughead, and Reggie were all handled by one singer: Ron Dante. The animated group had several equally animated hits, including "Sugar, Sugar." Dante later went on to produce Barry Manilow's albums and Broadway shows, and for two years he was the editor of *The Paris Review.*

3

In direct contrast to the Archies, KISS, according to founder Gene Simmons, was a real band pretending to be cartoon characters. Dressed in flashy clothes and caked in outrageous face makeup, the band used smoke and pyrotechnics to give themselves a larger-than-life quality, which their preteen fans found deafeningly appealing.

This classic *(right)* by Aladdin lunchbox artist Elmer Lehnhardt was based on photos from the Beatles' official photographer, Dezo Hoffman, and sold more than 600,000 units. It would have sold more if not for the fact that a month after the box went on sale, John Lennon made the unfortunate remark that the Beatles were "more popular than Jesus," provoking a massive backlash in America's Bible Belt.

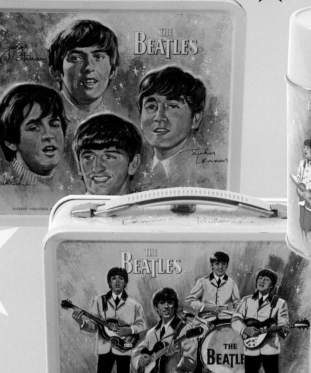

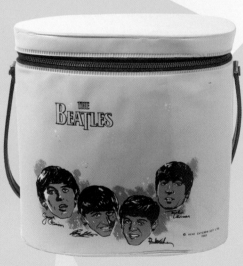

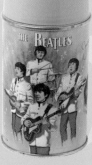

1. **The Beatles**
 Aladdin, 1965
 $$$$$

2. **The Beatles** *(brunch bag, also available in a shiny, superchic patent leather edition)*
 Aladdin, 1965
 $$$$

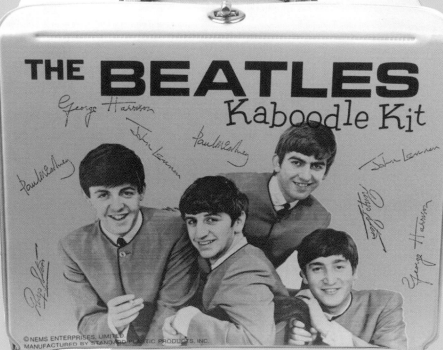

The "Air Flite" bag featured a black and white photo of the Fab Four. There was only one problem: the bags were unlicensed—created without the Beatles' authorization. Poorly constructed, these vinyl bootlegs were (according to lunchbox legend) cranked out in a Bronx loft.

3. **The Beatles**
 "Air Flite," 1964
 $$$$

4. **The Beatles**
 "Kaboodle Kit"
 Standard Plastic Products, 1964
 $$$$

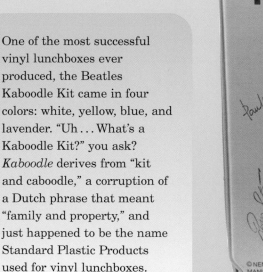

One of the most successful vinyl lunchboxes ever produced, the Beatles Kaboodle Kit came in four colors: white, yellow, blue, and lavender. "Uh … What's a Kaboodle Kit?" you ask? *Kaboodle* derives from "kit and caboodle," a corruption of a Dutch phrase that meant "family and property," and just happened to be the name Standard Plastic Products used for vinyl lunchboxes.

7

MOVIES

BIG-SCREEN FUN ON A LITTLE METAL BOX

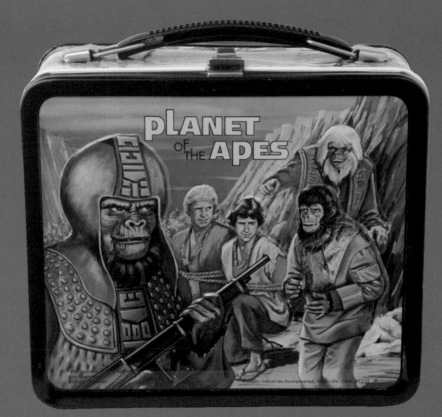

The first pop culture icons ever to appear on lunchtime paraphernalia were movie characters in the late 1930s, a marketing idea cooked up by creative dreamer Walt Disney and his business-savvy brother, Roy. Disney licensed rights to its earliest film stars—Mickey, Donald, Snow White, and the rest—for almost any product, including lunch pails. Roy Disney put it this way: "The sale of a product to any member of a household is a daily advertisement . . . for our cartoons and it keeps them all 'Mickey Mouse–minded.'" It took a few decades, but eventually Roy's credo spread. By the 1960s, many studios began looking for spin-offs, through which the merchandise sold the movie, and vice versa.

Although movie characters were the first to be featured on lunch pails, they weren't part of the first wave of lunchboxes. Even the Disney brothers held off issuing lunchbox rights to Mickey Mouse and Donald Duck until 1954—at which point they demanded that their own artists do the designs.

Despite their early prominence, movie characters would never achieve the same status among lunchbox carriers as those from TV series, and with good reason: TV shows aired weekly, allowing children to constantly renew their bonds to the characters. Movies, on the other hand, were one-time events. Unless they were especially memorable (*Star Wars*, for example) they quickly faded away in pre-VCR times.

This lunchbox *(below)* wasn't issued for the original *King Kong,* but for the laughable 1970s remake starring Jessica Lange. The movie flopped; the lunchbox didn't fare much better.

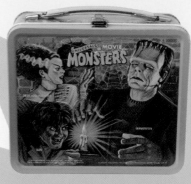

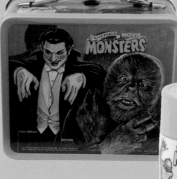

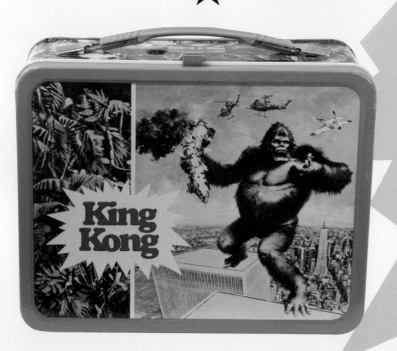

In a series of brilliant movies made in the 1930s, Universal Studios defined how we visualize the classic monsters to this day: Frankenstein, the Wolfman, the Phantom of the Opera, Dracula, the Mummy. The creatures are immortal, and their popularity returned in cycles, along with toys like monster models in the 1960s, eight-inch action figures, this Movie Monsters lunchbox in 1979 *(above),* and Burger King premiums in the 1990s.

In 1970, decades after Johnny Weissmuller's retirement, *Tarzan's Jungle Rebellion* featured newcomer Ron Ely, the fifteenth film actor to play Tarzan. The following year, *Tarzan* was sold as a TV series to NBC. Also starring Ely, Tarzan swung the television vines for two years. This lunchbox was issued after the movie's release and in anticipation of the television show.

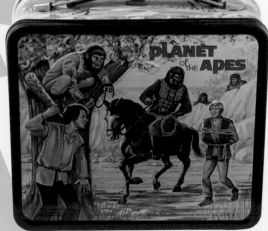

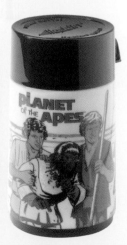

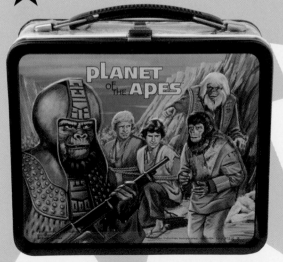

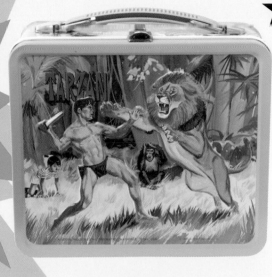

With bloody human sacrifices, reckless endangerment of child actors, and a feast of monkey-brain cuisine, *Temple of Doom* was the darkest, least kid-friendly of the three Indiana Jones movies. Strangely enough, *Temple of Doom* was the only movie of the trilogy to get its own lunchbox.

1. ***Indiana Jones and the Temple of Doom***
King Seeley, 1984
$

2. Peter Pan
Aladdin, 1969
$$

3. Sleeping Beauty
General Steelware, early 1960s
$$$

4. Pinocchio
Aladdin, 1971
$$

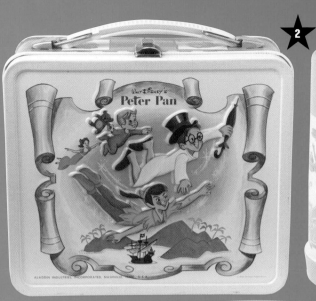

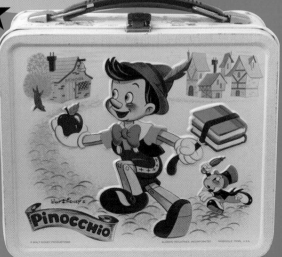

Disney classics were rereleased regularly as if they were new movies, and merchandising was likewise renewed. This Pinocchio lunchbox *(below)* came out with the 1971 rerelease of the 1940 movie. Likewise, the Sleeping Beauty *(left)* and Peter Pan *(above)* boxes coincided with rereleases, not the original premieres of the movies.

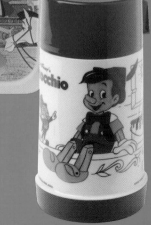

In 1938, a division of Libby Glass, the Owens Illinois Can Company, began producing Disney-licensed lunch pails with scenes from Mickey Mouse shorts, *Pinocchio*, and *Snow White*, like the two-handled models pictured here. In 1941, on the eve of America's entry into World War II, Owens Illinois was forced to close down the line.

1. *Pinocchio (round tin)*
Owens Illinois, 1940
$$

2. *Pinocchio*
Owens Illinois, 1940
$$

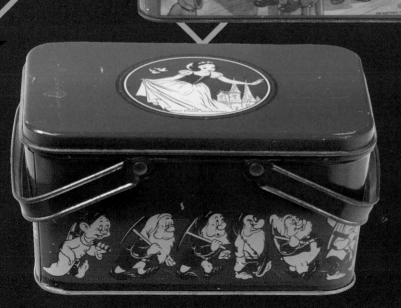

3. ***Snow White***
Belgium (maker unknown),
late 1930s–1940
$$

4. ***Snow White and the Seven***
Dwarfs
Owens Illinois, 1938
$$

Mary Poppins featured an all-star cast, including Julie Andrews and Dick Van Dyke surrounded by an innovative mix of live action and animation. Despite the movie's feast of visuals, for some reason Disney chose this uninspired illustration for the lunchbox *(right)*. *Chitty Chitty Bang Bang* starred several Disney alumni, including Van Dyke, and featured songs by longtime Disney songwriters the Sherman Brothers. The story centered on a magical flying car and was written by Ian Fleming, more famous for creating international superspy James Bond.

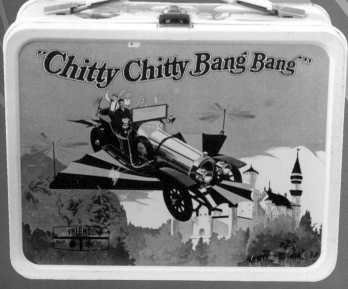

Another Disney movie mixing live actors and animation, *Bedknobs and Broomsticks* starred Angela Lansbury and Roddy McDowall, but never reached the success of its forerunner, *Mary Poppins*.

★ 3

Pete's Dragon starred Helen Reddy, Mickey Rooney, Shelley Winters, and a huge green dragon that only appears onscreen for a few moments at the end of the film. Originally, the dragon wasn't supposed to be seen at all—to save money, he was to be invisible, like Jimmy Stewart's invisible rabbit in the film *Harvey*—until wiser heads at Disney prevailed.

★ 4

3. *Bedknobs and Broomsticks*
 Aladdin, 1972
 $

4. *Pete's Dragon*
 Aladdin, 1978
 $

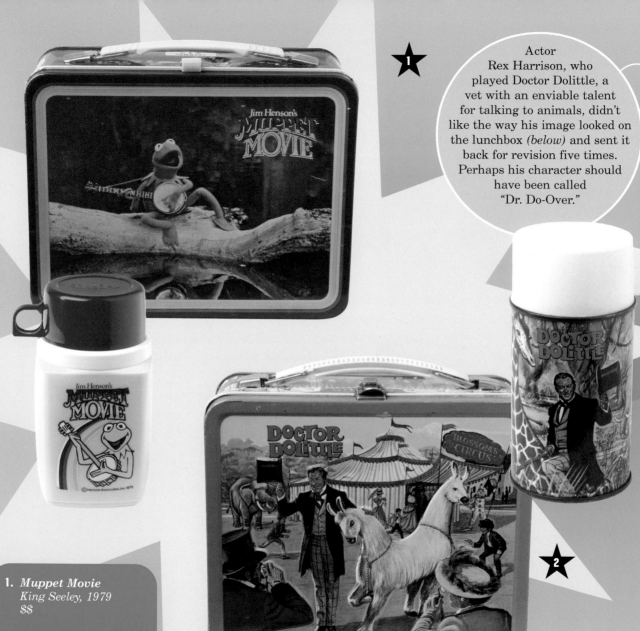

Actor Rex Harrison, who played Doctor Dolittle, a vet with an enviable talent for talking to animals, didn't like the way his image looked on the lunchbox *(below)* and sent it back for revision five times. Perhaps his character should have been called "Dr. Do-Over."

1. *Muppet Movie*
 King Seeley, 1979
 $$

2. *Doctor Dolittle*
 Aladdin, 1968
 $

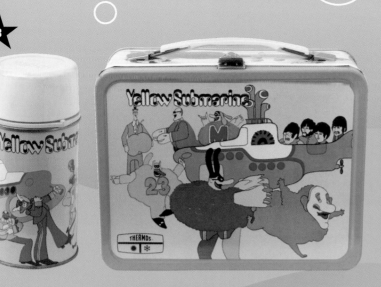

How do you make a movie when your rock band is wracked by internal feuds? Easy. Hire cartoonists and let the live actors work separately. The *Yellow Submarine* script was cowritten by Erich Segal, who later became famous for penning the tearjerker hit *Love Story*.

3. ***The Beatles, Yellow Submarine***
King Seeley, 1968
$$$$$

4. ***Voyage to the Bottom of the Sea***
Aladdin, 1967
$$$$

OUTER SPACE

SPACE

**BOLDLY GOING WHERE NO KID HAS
GONE BEFORE**

In the 1960s, the dream of space travel tickled the imaginations of kids of all ages and became a healing antidote to the cold war. Instead of dread and destruction, missiles became symbols of hope and exploration. Suddenly, it seemed possible that we'd shed the gravitational bond of earth and spend our lives zooming through space. By the distant year of 2001, we believed, there'd be colonies on Mars. Pan Am, a major airline, began taking reservations for future flights on a moon shuttle. Every space launch was broadcast live on all three networks. Kids in schoolrooms put aside their lessons to listen to live radio coverage.

The space fixation reached its zenith with Neil Armstrong's moonwalk in 1969. After attaining that giant step for mankind, however, the space program began to slow down and lost some of its mystique. Pan Am suspended reservations for lunar flights. NASA watched its budgets dwindle. It became clear that we wouldn't colonize Mars by the turn of the century.

As we adjusted our cosmological yearnings, our ideas about space aliens began to change, too. The recurring images in 1950s popular culture had been space monsters that conquered our cities, inhabited our brains, and even devoured us whole. The 1970s and 1980s brought the friendly aliens of *Close Encounters of the Third Kind*, and loveable, cuddly aliens, such as E.T., Yoda, and Chewbacca. Perhaps we were merely hoping that one of these happy space creatures would offer us a ride to places we could visit only in our minds.

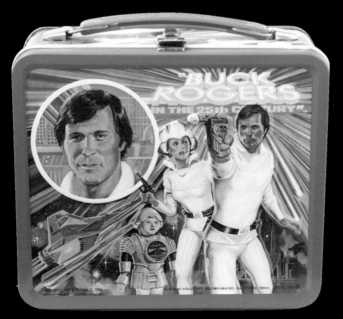

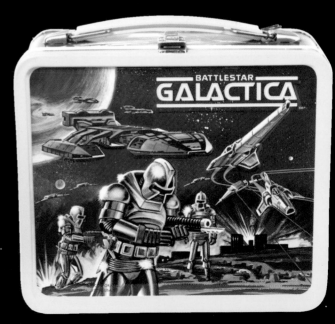

Space traveler William Anthony ("Buck") Rogers, has lived in the future for more than seventy-five years. In August 1928, the character first appeared in a novelette serialized in *Amazing Stories* magazine. From there, Buck zoomed his spaceship through comic strips, a radio serial, a 1939 film serial starring Buster Crabbe (who also played Flash Gordon in serials at the same time), and the 1980s TV series that spawned this lunchbox *(below)*.

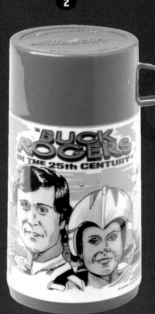

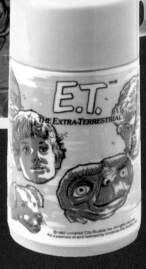

1

2

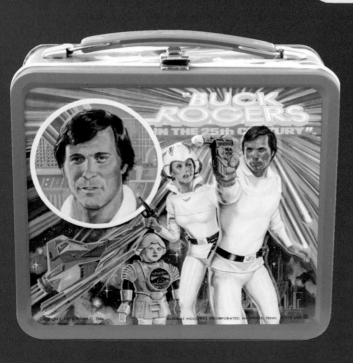

1. *E.T. the Extra-Terrestrial*
 Aladdin, 1982
 $

2. *Buck Rogers in the 25th Century*
 Aladdin, 1980
 $

3. Battlestar Galactica
Aladdin, 1979
$

4. Star Trek: The Motion Picture
King Seeley, 1980
$$

3

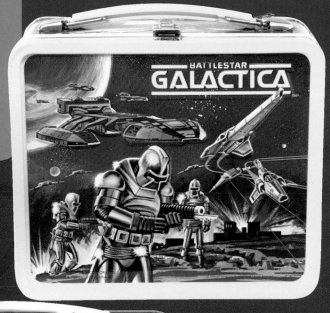

4

After a twelve-year absence from lunchboxes and the deck of the starship *Enterprise*, Captain Kirk, Spock, Scotty, Dr. McCoy, and the rest of the crew returned with this box and a motion picture. It was designed by Gene Lemery, who had been trained as a fine artist and who also designed other boxes such as The Empire Strikes Back, Pelé, The Fonz, and Knight Rider.

STAR WARS ™

①

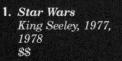

When artist Don Henry designed the first Star Wars lunchbox in 1977, he misjudged the film's appeal. His front design showed spaceships; the back, Luke Skywalker, Obi-Wan Kenobi, and 3-CPO surrounded by stormtroopers. But wait—where were Han Solo, Princess Leia, R2-D2, and Darth Vader? In 1978, King Seeley revised the box, replacing the starry side panels with new artwork of the missing characters *(above)*. By the time the sequels came out, they seemed to have figured out what they were doing.

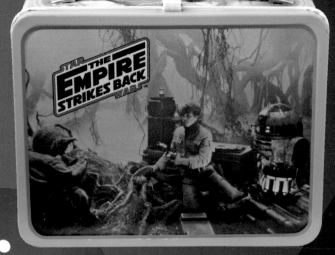

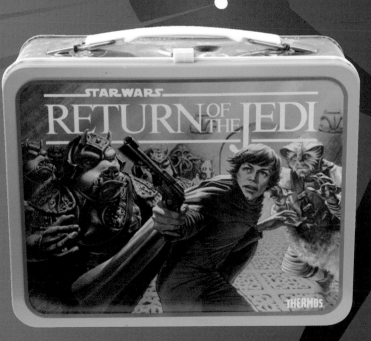

**2. The Empire
Strikes Back**
(spaceship)
King Seeley, 1980
$

**3. The Empire
Strikes Back**
(swamp)
King Seeley, 1981
$$

**4. Return of the
Jedi**
King Seeley, 1983
$

When Disney tried its hand at science fiction, *The Black Hole* was the result. With a spaceship that looked like a flattened Eiffel Tower, the movie had the best special effects available in 1979. The thermos and back of the lunchbox show evil robot Maximillian shooting a death ray at cartoonish good-guy robots V.I.N.CENT. and Bob. Owing to its dark subject matter, and weird, *2001*-like ending, this was the first Disney movie to get a PG instead of a G rating.

1

2

1. **The Black Hole**
 Aladdin, 1979
 $

2. **Captain Astro**
 Ohio Arts, 1966
 $$$

3. *Space Travel*
DecoWare, 1930s
$$

4. *Astronaut Mini*
Lunch Box
Clein company,
early 1960s
$

mini LUNCH BOX
REG PEND

From the days of early Buck Rogers and Flash Gordon comics and movie serials, this two-handled lunch pail *(above)* captured the excitement of moon travel and space walks. The spaceships look plausible enough; the feasibility of mushroom-shaped crafts drifting like parachutes toward the moon's surface through its incredibly thin atmosphere is another matter.

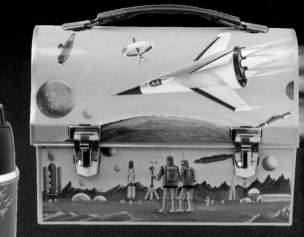

In this lushly illustrated dome box designed by artist John Polgreen *(right),* a space couple saunters through a human-trashed Mars landscape. Above them, a spaceship flies through space objects that look like an orange, a flying Wienermobile, a felt-tipped marker, and a toy gyroscope.

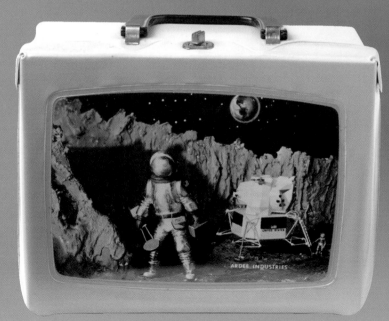

1. *Astronaut*
 King Seeley, 1960
 $$

2. *Lunar Landing* (vinyl)
 Ardee, early 1960s
 $$

Take a spaceometer and a rocket vibromotcr [sic] sensor, then add some rocket-power switches and navigational knobs—what space traveler wouldn't feel at home with this retro-futuristic rocket dashboard *(below)*? And when the space traveler gets hungry, there's a sandwich and fruit cup inside! The Vanguard IV thermos comes with nose cone and fins and (according to the Universal promotional literature of the time) is "scientifically tested to withstand orbiting youngsters."

U.S. SPACE CORPS

VANGUARD IV

In 1962, John Glenn became the first American to orbit the Earth, and a year later the Orbit lunchbox commemorated his feat. Although Glenn soared, this box came crashing to the ground when *National Geographic* editors discovered that the space capsule illustration had been copied directly from its pages. King Seeley immediately stopped production.

1. *Satellite*
 King Seeley, 1960
 $$

2. *Orbit*
 King Seeley, 1963
 $$$

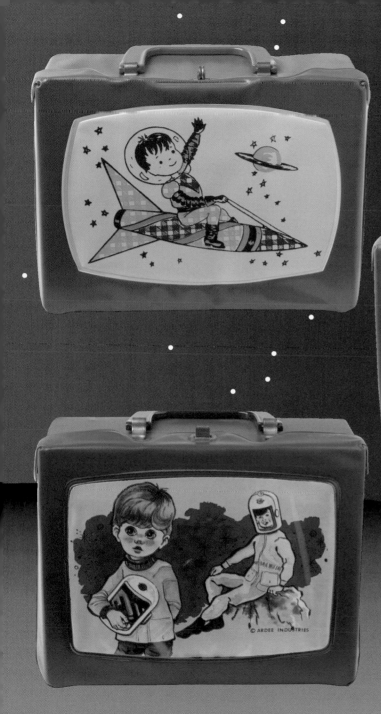

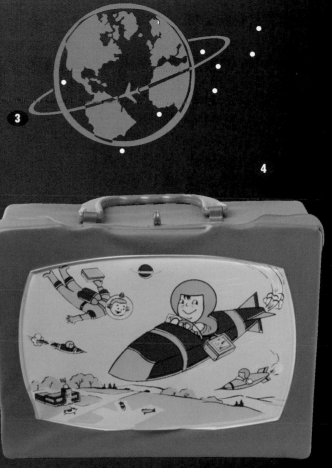

3. **Space Kids**
 Ardee, early 1960s
 $$

4. **Spacekid**
 (over schoolhouse)
 Ardee, early 1960s
 $$

5. **Space Boys**
 Ardee, early 1960s
 $

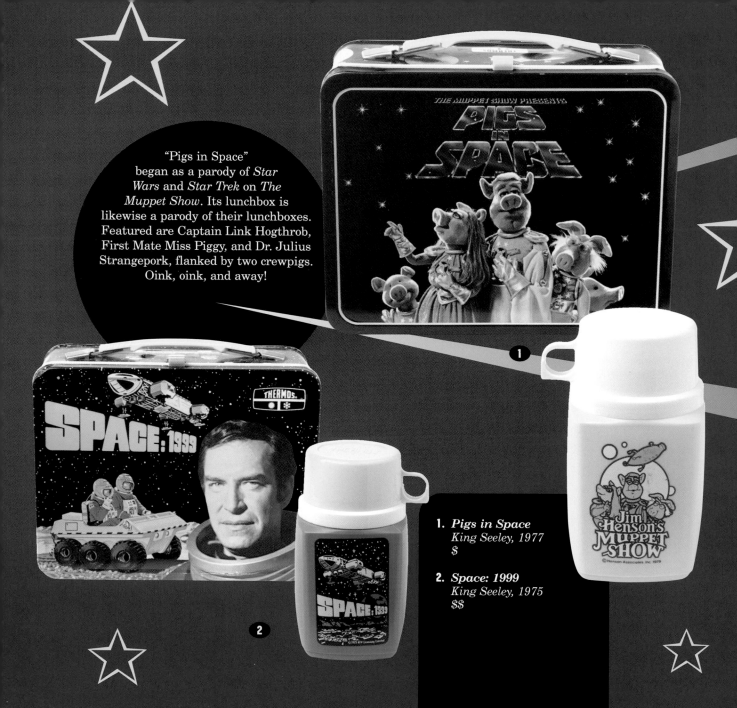

"Pigs in Space" began as a parody of *Star Wars* and *Star Trek* on *The Muppet Show*. Its lunchbox is likewise a parody of their lunchboxes. Featured are Captain Link Hogthrob, First Mate Miss Piggy, and Dr. Julius Strangepork, flanked by two crewpigs. Oink, oink, and away!

1. *Pigs in Space*
 King Seeley, 1977
 $

2. *Space: 1999*
 King Seeley, 1975
 $$

3. Mike Mercury's Supercar Orbital Food Container
Universal, 1962
$$$

An import from England, *Supercar* was unusual in that its characters never stopped smiling no matter how scared, tense, or sad they became. This was less a function of their stiff-upper-lip British bravery than the fact that they were all marionettes. Despite their often-visible strings and herky-jerky movements, Mike Mercury, Jimmy Gibson, Professor Rudolph Popkiss, Mitch, and Dr. Horatio Beaker guided their air, land, sea, and space car into the hearts of kids in two countries, and onto this lunchbox in the States.

MIKE MERCURY'S
SUPERCAR
ORBITAL FOOD CONTAINER

3

ALADDIN INDUSTRIES INCORPORATED, NASHVILLE, TENN., U. S. A.

1

STAR TREK

Framed, for some reason, by riveted steel more at home in 1930s construction projects than futuristic spaceships, Leonard Nimoy and William Shatner brandish a clunky-looking communication device and weapon as Dr. Spock and Captain Kirk. The bottom of the box shows most of the TV cast lounging on the bridge of the starship *Enterprise*. Although Aladdin made about a quarter-million boxes, the demand and price for this one remain sky-high.

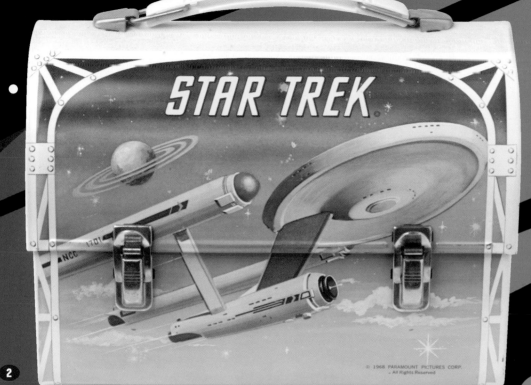

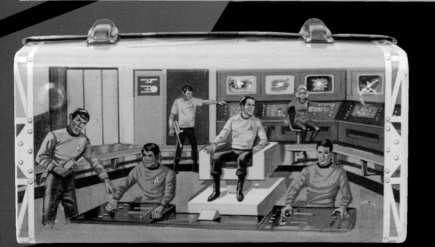

1. **Star Trek Dome** *(back)*
 Aladdin, 1968
 $$$$$

2. **Star Trek Dome** *(front)*
 Aladdin, 1968
 $$$$$

3. **Star Trek Dome** *(base)*
 Aladdin, 1968
 $$$$$

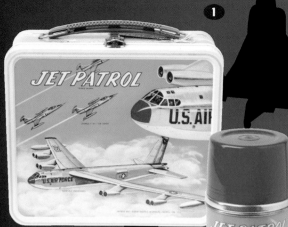

1 ①

1. **Jet Patrol**
 Aladdin, 1957
 $$$

2. **Steve Canyon**
 Aladdin, 1959
 $$$

3. **Lost in Space**
 King Seeley, 1967
 $$$$

Steve Canyon, Milt Caniff's long-running cartoon strip, inspired a short-lived TV series, for which this box *(below)* was designed. Caniff's specialty was stiff-looking people posing in front of lovingly drawn warplanes, and this box doesn't disappoint. Not surprisingly, since Caniff didn't trust anybody else with his character, he designed it himself.

T he coolest thing about this generic box (above) showing state-of-the-art warplanes was the key on the inside of the box to help kids—and probably Russian spies as well—identify the military planes of the era. The thermos shows an experimental boondoggle called the Pogo that was supposed to take off and land vertically. Because it was prone to crashing, only two Pogo prototypes were made before the project was shelved.

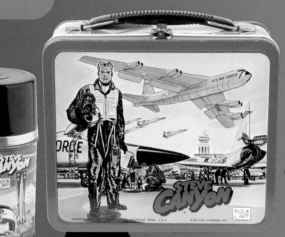

2 ②

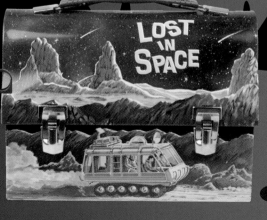

3 ③

Lost in Space, based loosely on the shipwrecked family of *Swiss Family Robinson*, featured the Robinsons, the best-equipped suburban space family in all of the cosmos. The front *(left)* shows a space SUV; the back, a tract house–styled spaceship, carnivorous plants, and that robot that shouted "Danger! Danger! Will Robinson!" on every show.

"That's one small step for a lunchbox..." This box *(below)* commemorated astronaut Neil Armstrong's first step on the moon. The bottom of the box shows a somewhat dubious bit of moon memorabilia: a plaque left on the moon by Armstrong signed by then-president Richard M. Nixon.

4. Space Shuttle Orbiter Enterprise
King Seeley, 1977
$

5. The Astronauts
Aladdin, 1969
$$

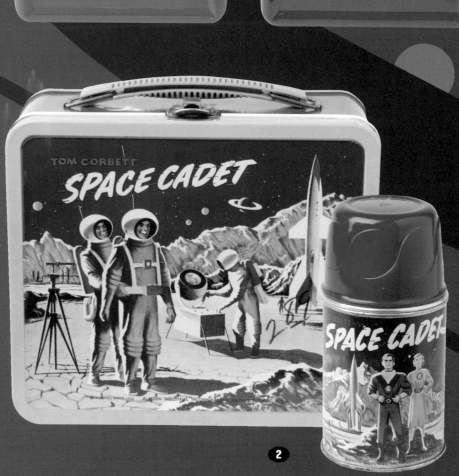

Tom Corbett, Space Cadet bounced from network to network in the early days of television, appearing on CBS, ABC, NBC, DuMont, and again on NBC in the years from 1950 to 1955. The back shows a severely out-of-scale map of our solar system; the front originally featured a self-portrait of its artist Bob Burton as a space cadet floating through space in the background, but the Aladdin art director made him take it out. He later got away with a similar trick by putting his face on coins that appeared on the Buccaneer dome (see page 132).

1. **Tom Corbett Space Cadet**
 (red and blue boxes)
 Aladdin, 1952
 $$

2. **Tom Corbett Space Cadet**
 (full lithograph box)
 Aladdin, 1954
 $$$

3. *Fireball XL5*
King Seeley, 1964
$$$

4. *Colonel Ed McCauley*
Space Explorer
Aladdin, 1960
$$$

What did *The Howdy Doody Show* and *Fireball XL5* have in common? They both starred marionettes. The lunchbox *(left)* shows the show's wooden main characters Colonel Steve Zodiac and lovely Dr. Venus. Meanwhile, their futuristic XL5, sporting fins like a 1959 Cadillac, is taking off without them, needlessly endangering the citizens of Space City in the background.

The TV show *Men Into Space* featured William Lundigan, who played the role of Colonel Ed McCauley. McCauley worked from a moon-based space station where each week he encountered adventures ranging from moonquakes and asteroids to saboteurs and budget cuts. The show aired for two years from 1959 to 1961. Angie Dickinson played Ed's wife in the pilot, but Joyce Taylor replaced her in the series.

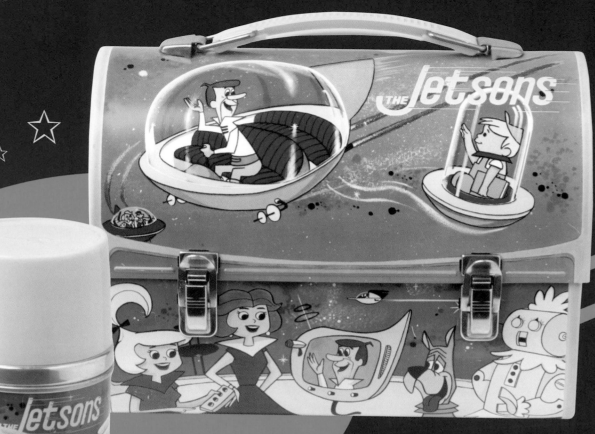

"Meet George Jetson; Jane, his wife…." *The Jetsons*, set in the future, was Hanna-Barbera's attempt to strike some kind of chronological balance with their other hit show, set in prehistory, *The Flintstones*. The bottom shows the loveable cartoon family at a space diner ordering flying pizzas and space ice cream; the dog, Astro, salivates over a genetically modified T-bone steak.

The Jetsons *(front, back, and base)*
Aladdin, 1963
$$$$$

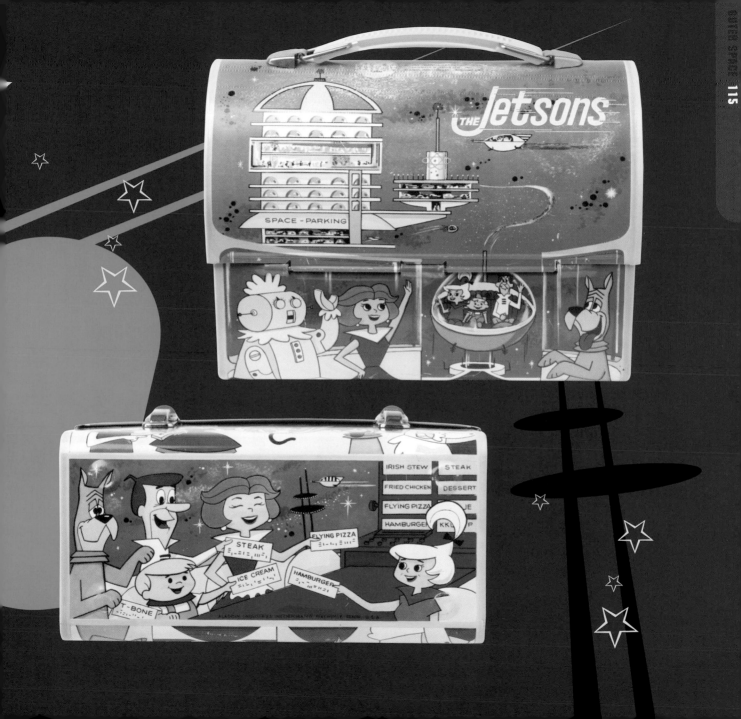

9

TOUGH GUYS & GALS

EVERYBODY WAS KUNG-FU FIGHTIN'

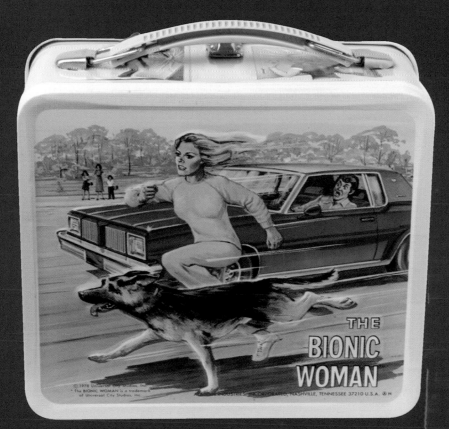

When you're a kid, the world can be a scary place, especially when it becomes clear that your parents are just people, and can't magically protect you from every imaginable danger. In response, many kids dream of becoming (or at least befriending) superheroes; others turn to tough, invulnerable television stars as fantasy role models. Lunchbox makers were quick to capitalize on the perennial appeal of the cops, army grunts, detectives, firefighters, spies, and martial-arts experts who could save the day if things ever got out of hand during recess. Ostensibly human, these macho do-gooders are enhanced by a few extra dollops of courage, strength, intelligence, good looks, great hair, and, in two notable cases, bionic body parts.

Traditionally, of course, tough guys were exactly that—guys. Women were noticeably absent from lunchboxes throughout the 1960s. With the emergence of the feminist movement in the 1970s, however, gals like the Bionic Woman and Charlie's Angels were given an equal opportunity to brandish guns and beat the crap out of evildoers. If that isn't a real measure of human progress, what is?

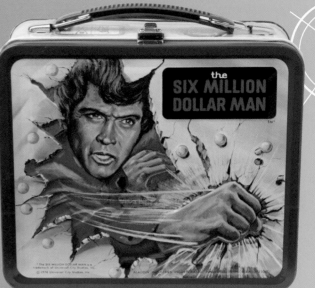

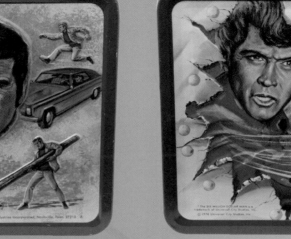

Every '70s kid remembers Steve Austin, a NASA test pilot who was rebuilt ("better than before") after being horribly mangled in a plane accident. Starring actor Lee Majors, *The Six Million Dollar Man* was inspired by Martin Caidin's science-fiction novel *Cyborg*. Six million dollars of the taxpayers' money went into transforming Colonel Austin into a superhuman machine; in return, Austin was obligated to undertake dangerous, top-secret missions for the government. The second box *(above, right)* was released four years later—the same year the series went off the air. In 1976, a spinoff series, *The Bionic Woman*, debuted, and Aladdin issued a box for it as well.

The Bionic Woman, starring Lindsay Wagner as special agent Jaime Sommers,

inspired two lunchboxes *(opposite page)*. Or, more accurately, one and a half, as both boxes had the same image on the front: Sommers in a classroom, tearing a (presumably evil) telephone book in half. The back of the 1977 box showed Sommers stopping a car by digging in one of her bionic heels. The 1978 box pictured her alongside her bionic dog, Max, as they outran a speeding car. The brunch bag *(right)* was aimed at older, more sophisticated girls. It was fashioned like a purse and could be slung over the shoulder.

1. *The Six Million
Dollar Man*
Aladdin, 1974
$

2. *The Six Million
Dollar Man*
(punching)
Aladdin, 1978
$

3. *The Bionic Woman*
(brunch bag)
Aladdin, 1977
$$$

4. *The Bionic Woman*
(with dog)
Aladdin, 1978
$$

5. *The Bionic Woman*
(braking with foot)
Aladdin, 1977
$$

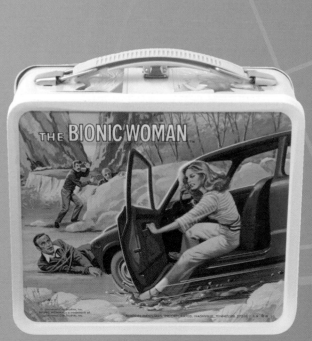

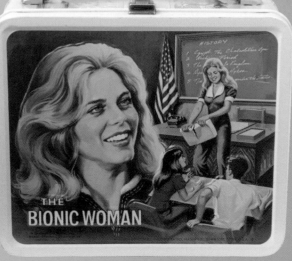

*K*ung Fu, a uniquely original television series that ran from 1972 to 1975, starred David Carradine as a renegade Asian martial-arts master who wandered through the Wild West of the 1870s seeking peace, justice, and a half brother he never met. Always reluctant to open a can of whup-ass on the bad guys, he became famous for spouting fortune-cookie wisdom: "Remember always: A wise man walks with his head bowed, humble like the dust."

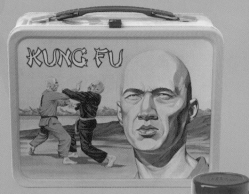

1. **Kung Fu**
 King Seeley, 1974
 $

2. **The Fall Guy**
 Aladdin, 1981
 $

3. **Charlie's Angels**
 (brunch bag; vinyl, with shoulder strap)
 Aladdin, 1977
 $$

4. **Charlie's Angels**
 Aladdin, 1978
 $

After *The Six Million Dollar Man*, Lee Majors starred in *The Fall Guy* in the 1980s as a movie stunt man who moonlights as a bounty hunter. The front of the box *(left)* shows a studly looking Majors as his character performs a wall-of-flame stunt in the background; the back features him jumping from a helicopter into the back of a pickup truck. The series was hugely popular with lunchbox-age kids, which makes this particular box relatively easy to come by.

Farrah Fawcett-Majors had already left *Charlie's Angels* when the tie-in lunchbox was issued featuring Jaclyn Smith, Kate Jackson, and Farrah's replacement, Cheryl Ladd *(below)*. On this single piece of merchandising, viewers were allowed to see more of Charlie (his hand, holding a phone) than ever appeared on the television screen, where he was represented by the disembodied voice of actor John Forsythe. The fashionable brunch bag *(left)* featured a 100 percent vinyl exterior and a shoulder strap.

© 1977 Spelling-Goldberg Productions
All Rights Reserved

ALADDIN INDUSTRIES INCORPORATED, NASHVILLE, TENN. 37210 USA

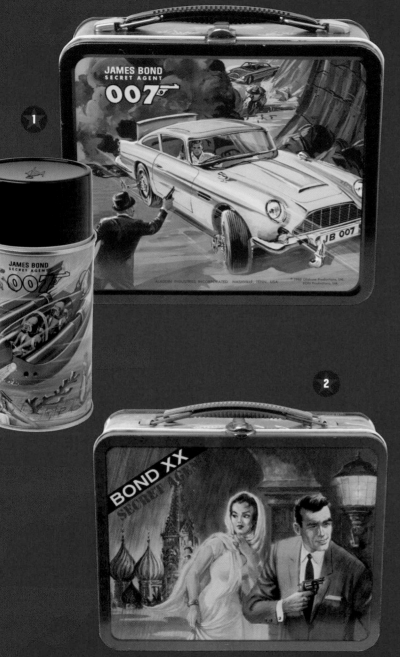

With the film *Thunderball*, released in 1965, audiences were treated to the first (and some say best) actor to play James Bond, Sean Connery. President John F. Kennedy contributed greatly to 007's popularity when he confessed to the guilty pleasure of reading Ian Fleming's action-packed series of spy novels. Fleming, an avid birdwatcher, took his character's name from the author of *Birds of the West Indies*, the ornithologist James Bond.

By the late 1960s, James Bond was so popular that the character had spawned imitators—and knockoff products that bordered on trademark infringement. Bond XX, designed to deceive unwitting schoolchildren, was one such item. The name on the box should really have read "Bond Double-Cross."

If *The Man from U.N.C.L.E.* lunchbox characters seem to be drawn with comic-book flair, there's a reason: Jack Davis, an idiosyncratic illustrator (whose work appeared in *MAD* magazine) designed the box. Although the show's producers claimed the letters of U.N.C.L.E. and T.H.R.U.S.H. didn't stand for anything, according to one of the novels based on the series, they stand for "United Network Command for Law and Enforcement" and "Technical Hierarchy for the Removal of Undesirables and the Subjugation of Humanity."

Sorry about that, chief! Don Adams starred as Agent 86 in Mel Brooks's legendary spy parody *Get Smart,* which premiered in 1965 with just enough sophomoric humor to appeal to children and adults alike. Especially inventive were the gadgets: Who didn't want a shoe phone, or a phone booth that led to a secret headquarters? Would you believe that this lunchbox carries a fully functional hydrogen bomb? Would you believe it carries a machine gun? How about a sandwich, an apple, and a thermos of milk?

A rival to G.I. Joe and other action figures, Action Jackson was the brainchild of the Mego Corporation, a struggling toy company that "borrowed" basketball player Phil Jackson's nickname because they couldn't afford to license a real character's name. The boxes featured Action Jackson in one of several invented scenarios working as a firefighter, or wearing a jet pack. Ironically, the lunchbox images came from advertisements for the action toy that almost sunk the toy company— they violated National Association of Broadcasters' rules about using unrealistic simulations while selling products to kids.

Adam-12 ran on NBC from 1968 to 1975. The front of the box shows Los Angeles police officers Pete Malloy and Jim Reed drawing their guns for a shootout. The back (not shown) depicts them making heroic efforts to protect a runaway puppy. Police Patrol was yet another generic knockoff that Aladdin hoped would capitalize on the popularity of television cop shows.

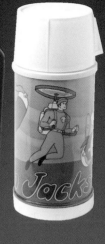

1. *Action Jackson*
 Universal, 1973
 $$$$

2. *Adam-12*
 Aladdin, 1973
 $$$

3. *Police Patrol*
 Aladdin, 1978
 $$

4. *Emergency!*
 Aladdin, 1973
 $$

5. *Emergency!* *(dome)*
 Aladdin, 1977
 $$$

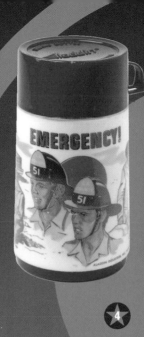

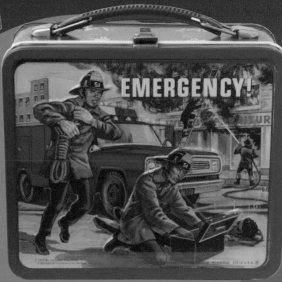

Despite this lunchbox's heavily dramatic scenes, the *Emergency!* television series mixed daring rescues with humor, winning over kids and adults alike. The front shows a fire and EMS situation, the back (not shown) shows firemen rescuing two frightened kids who somehow got stranded on high-rise girders at a city construction site. Four years after the first Emergency! lunchbox, Aladdin released a dome version. The rounded form allowed the designer to show all four sides of a fire truck. The front shows EMS technicians trying to save a man who appears to have been run over by the fire truck.

5

Consider the irony. In the mid-1980s, concerned moms complained that metal lunchboxes were being used as weapons on the playground and pressured lawmakers to ban them. So what was the last metal lunchbox produced in the 1980s? The ultraviolent Rambo box featuring Sly Stallone. Incidentally, many collectors believe that manufacturers readily accepted the ban because cheaper plastics yielded a higher profit margin.

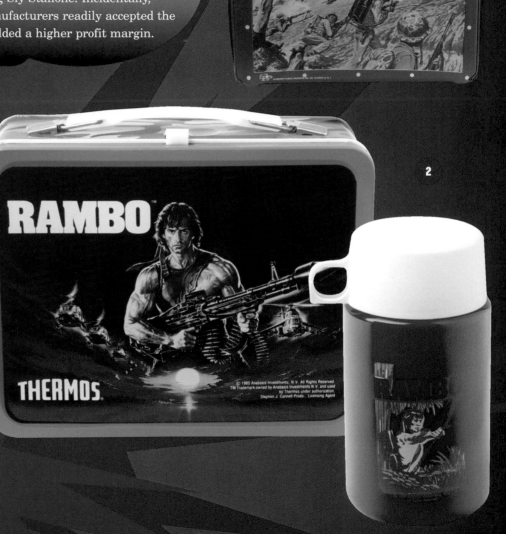

1. *Combat Man's Ammo Case*
 Standard Plastic Products, 1960s
 $$$

2. *Rambo*
 King Seeley, 1985
 $

Four Allied commandos fighting in two Jeeps against General Rommel's entire elite German Afrika Korps and the occasional Arabs was the gist of *The Rat Patrol*. The TV show was filmed partly in Spain, and made use of sets and props left over from the filming of *The Great Escape* and *The Battle of the Bulge*.

3. *Battle Kit*
American Thermos, 1965
$$

4. *The Rat Patrol*
Aladdin, 1967
$$$

There were at least four G.I. Joe lunchboxes produced after Hasbro introduced the legendary toy soldier in 1964. In the late 1960s, when America was turning against the Vietnam War and militarism, G.I. Joe ended up doing more quasi-civilian things like saving lives, fighting pollution, and becoming a kung-fu master. In 1978, Hasbro suspended production of the toy because of a dramatic rise in the cost of oil, a key component of plastic. Four years later, the company brought back Joe in a smaller, $3\frac{3}{4}$-inch size.

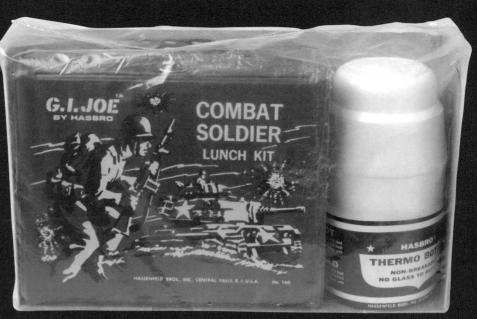

1

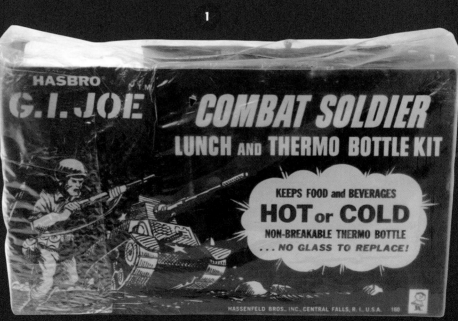

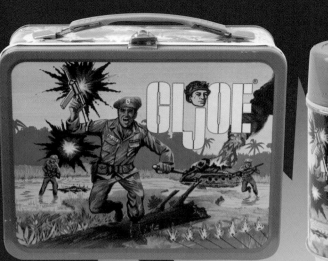

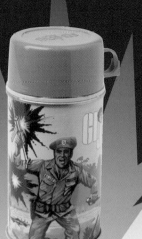

1. **G.I. Joe Combat Soldier lunch kit** *(vinyl)*
 Hasbro, late 1960s or early 1970s
 $$$ *(with original packaging)*

2. **G.I. Joe**
 King Seeley, 1967
 $$

3. **G.I. Joe: A Real American Hero**
 King Seeley, 1982
 $

10

SUPERHEROES

EVILDOERS? BRING 'EM ON!

What collectors refer to as the "black Zorro"—so called because of the color of the band that frames the image—came out in 1958 when *Zorro* first appeared on television. The "red Zorro" box came out eight years later when the TV series was re-released. By that time, actor Guy Williams was appearing in *Lost in Space* as Professor Will Robinson. Disappointed that his starring character was upstaged by the robot and by the comic bad guy, Dr. Smith, he eventually quit the series and—like Zorro himself might have done—retired to a ranch in Argentina.

I t's a scary world, and kids need heroes to look up to. For many years, such figures were essentially normal people (Robin Hood, say, or Zorro) whose strength, skill, bravery, and fabulous costumes allowed them to take risks that ordinary men could not.

Extraordinary times, however, require extraordinary heroes. The superhero craze of the twentieth century began in 1936, at the height of the Great Depression and with the ominous rise of the Nazis in Europe. That year saw the emergence of Superman and the Phantom, both of them masked do-gooders. In those desperate times, superheroes offered children a psychologically satisfying fantasy protector, someone who could scare away bogeymen in the middle of the night. Superman's enormous popularity spawned many future generations of superheroes, several of whom live among us still, ready to face down the dastardly bad guys, wherever they may lurk.

Buccaneer was the first dome lunchbox decorated for kids. Aladdin took the old workingman's design and decided it looked like a pirate's treasure chest. (Later that same year King Seeley did the same thing, using the rounded shape to simulate a classic barn.) Although not an authorized box, Buccaneer owed a lot of its success to a swashbuckling television program of the same name that had come out the year before. Lunchbox legend has it that the box's artist, Bob Burton, put his self-portrait on the ten real coins.

Whatever *Sesame Street* was able to accomplish on behalf of the ABCs, Disney's *Zorro* made even greater strides for *Z* by encouraging kids everywhere to practice carving the letter with their swords. (In fact, one company even put out a toy Zorro sword with a piece of chalk on its tip, so kids could practice wherever they went.) This box is from 1958; a similar box was issued in 1966, when the TV series was resyndicated. By that time the actor who played Zorro, Guy Williams, had been cast as Professor Robinson on *Lost in Space*.

1. *Buccaneer*
 Aladdin, 1957
 $$$

2. *Zorro (black)*
 Aladdin, 1958
 $$$$

3. *Robin Hood*
 Aladdin, 1956
 $$

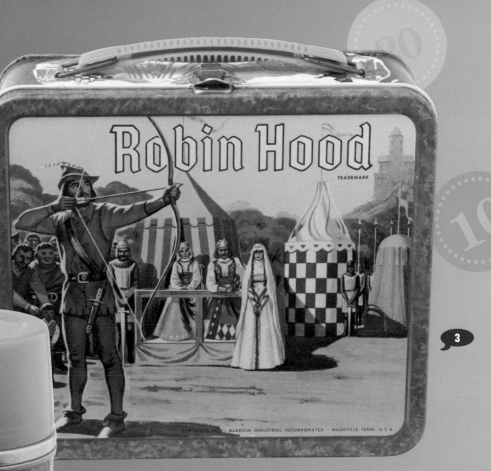

Foreshadowing *Masterpiece Theatre* by decades, *The Adventures of Robin Hood* was a high-quality British television import. Filmed entirely in England by Nettleford Studios, which made the settings and accents authentic, the show lasted on CBS from 1955 to 1960, burning its "Robin Hood, Robin Hood, riding through the glen..." theme song into the brains of an entire generation.

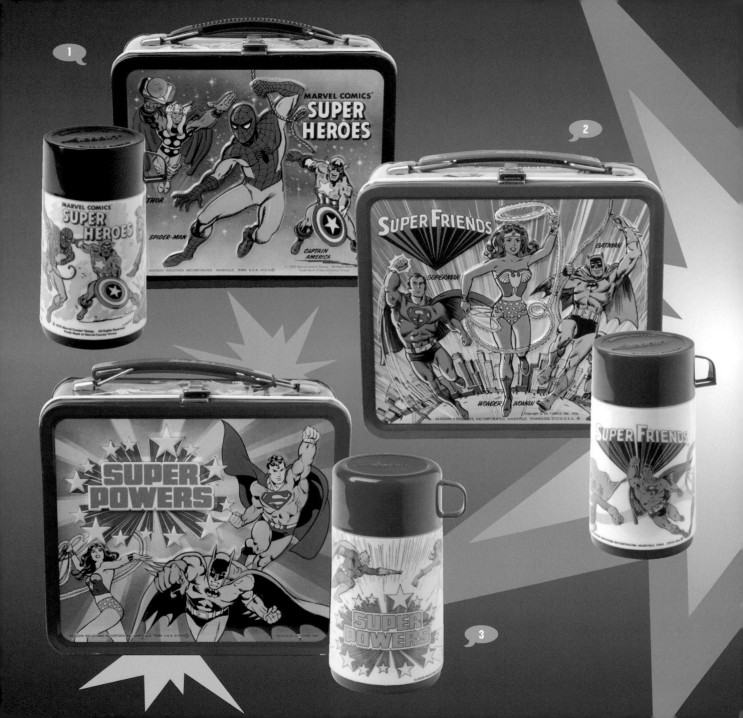

1. **Marvel Comics' Super Heroes**
 Aladdin, 1976
 $$

2. **Super Friends**
 Aladdin, 1976
 $

3. **Super Powers**
 Aladdin, 1983
 $

4. **Wonder Woman**
 (yellow vinyl),
 Aladdin, 1983
 $

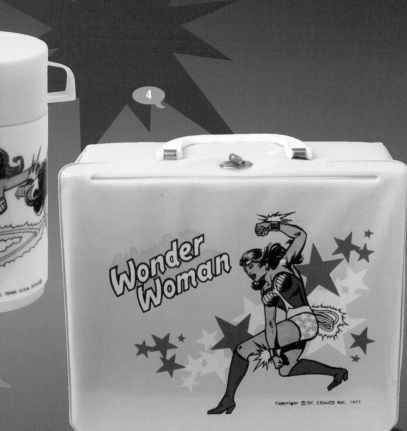

Aladdin cashed in on the comic book hero craze of the late 1970s with boxes representing the Super Friends cartoons, the Marvel comic-book heroes, and, most notably, Wonder Woman. You'll note that this Wonder Woman box didn't show Lynda Carter, the star of the popular show that was running at the time, but the comic-book Wonder Woman. She had been created in the 1940s by psychologist William Moulton Marston, the eccentric inventor of the technology behind the lie detector test, in an effort to get young, male comic-book readers used to the idea of being ruled by women. "Wonder Woman is psychological propaganda for the new type of woman who should, I believe, rule the world," Marston wrote. "There isn't love enough in the male organism to run this planet peacefully.... I have given Wonder Woman this dominant force but have kept her loving, tender, maternal, and feminine in every other way."

1

2

E arly issue Superman boxes all depicted the comic strip, not the popular live-action TV series starring George Reeves. Universal thought Reeves didn't really have what it took to sell boxes to kiddies, so Superman comics artist Wayne Boring provided the artwork. By the 1960s, the Superman cartoon came out and King Seeley had a hit with a lunchbox based on that. Finally in 1978, Aladdin found another "Reeve" Superman they liked: Christopher Reeve, who starred in the hit movies. There are very few 1954 boxes and they are in large demand, making them worth mortgaging the house for serious collectors.

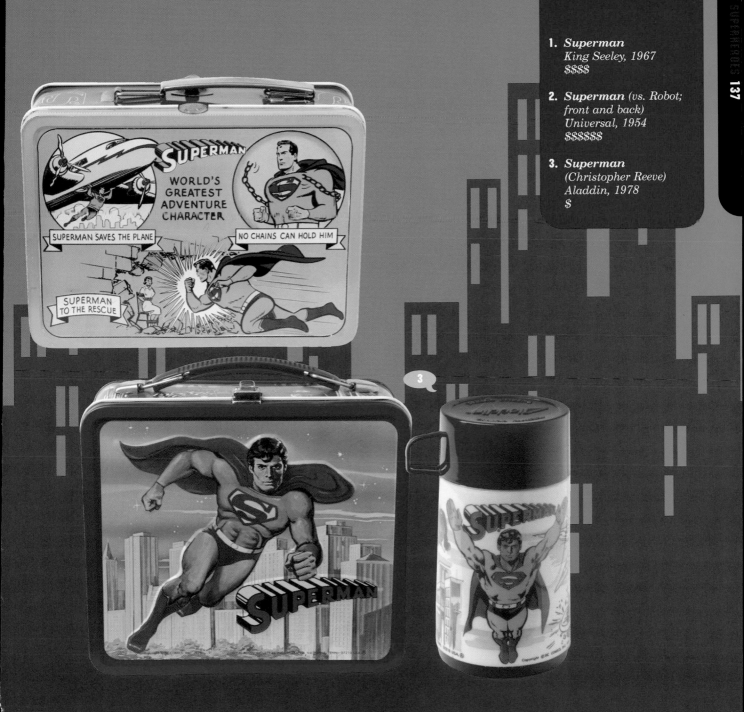

1. **Superman**
 King Seeley, 1967
 $$$$

2. **Superman** *(vs. Robot; front and back)*
 Universal, 1954
 $$$$$$

3. **Superman**
 (Christopher Reeve)
 Aladdin, 1978
 $

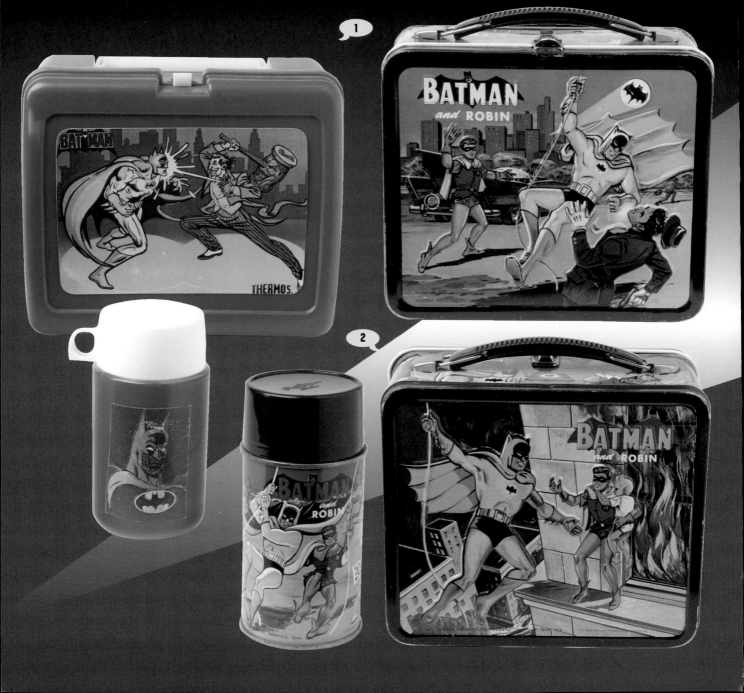

The Green Hornet had his own show in 1967, but he began in the 1940s as a character in a radio drama. What few people know, however, is that the Green Hornet is the Lone Ranger's grandnephew. George W. Trendle and Fran Striker, the creators of both characters, created this lineage: John Reid's brother Dan was killed by outlaws, so he donned a mask and began fighting evil as the Lone Ranger. John's nephew, Dan Jr., kept a portrait of the masked Ranger in his house; when his son, newspaper publisher Britt Reid, learned the truth about his grandfather and great uncle, he decided to take up the fight himself, becoming the legendary Green Hornet. On the lunchbox, that's Bruce Lee in the background. On the TV show, he played the Green Hornet's trusty sidekick, Kato.

3

1. **Batman** *(prototype, with hand-drawn graphics)*
King Seeley, 1982
$$

2. **Batman and Robin** *(front and back)*
Aladdin, 1966
$$$$

3. **The Green Hornet**
King Seeley, 1967
$$$

NORTH AMERICANA

MAPS, MYTHS & FLAGS

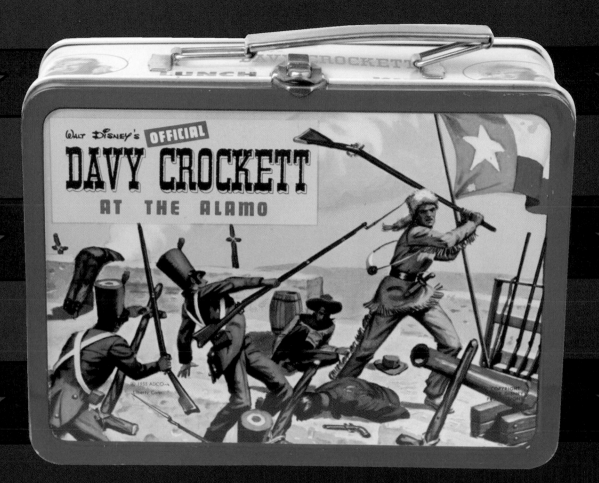

During the height of the lunchbox craze, boxes usually promoted movies, television shows, cartoons, toys, and sports teams. The boxes with various images of Americana were an anomaly, promoting mostly a love of country and its native mythology. Davy Crockett didn't really go down swinging his rifle butt at the Alamo, and Casey Jones wasn't particularly heroic. Regardless, the rugged frontiersmen, flags, maps, and other North American icons often sold quite well. So stand up and salute—the great American lunchboxes are marching by.

The early 1970s were a politically charged time as Nixon's presidency crumbled, and Teamsters beat up members of a growing opposition to the war in Vietnam. As the country polarized into rigid camps, conservatives used flag-flying to express their support of the war and the president, and their condemnation of "hippies," antiwar marchers, and civil rights activists. "Wake up, America!" became the rallying cry of the ultra-Right John Birch Society, and it somehow ended up on the side panels of this lunchbox *(right)* as well.

USA

a THERMOS brand PRODUCT

CALIFORNIA · ARIZONA · WASHINGTON · WYOMING · KENTUCKY · ILLINOIS · KANSAS · MISSISSIPPI · MONTANA · NEBRASKA · NEW HAMPSHIRE · UTAH · VERMONT · W. VIRGINIA · TEXAS · RHODE ISLAND · NEW YORK · NEW JERSEY · MINNESOTA · OHIO · WISCONSIN · FLORIDA · N. CAROLINA · GEORGIA

EXCLUSIVE THERMOS. FEATURES

See the sights, major industries, or stereotypes of all the forty-eight contiguous states without leaving your school cafeteria *(left)*. Ohio? Probably the smokestacks and tire. Wisconsin? Um, maybe the cow and barn. Texas? The cowboy? The oil wells? Hey, where are the answers on this thing?

1. **Wake Up, America!**
 Universal, 1973
 $$

2. *Americana*
 American Thermos, 1958
 $$$

3. *All-American*
 Universal, 1954
 $$$

4. *Flag-o-rama*
 Universal, 1954
 $$$

Do you see yourself as a citizen of the world instead of just one nation? Careful, friend—it's 1954, and Senator Joe McCarthy might haul you before the Senate un-American activities committee. Better not carry the Flag-o-rama, a lunchbox featuring the flags of the United Nations, or your friends might think you're a commie.

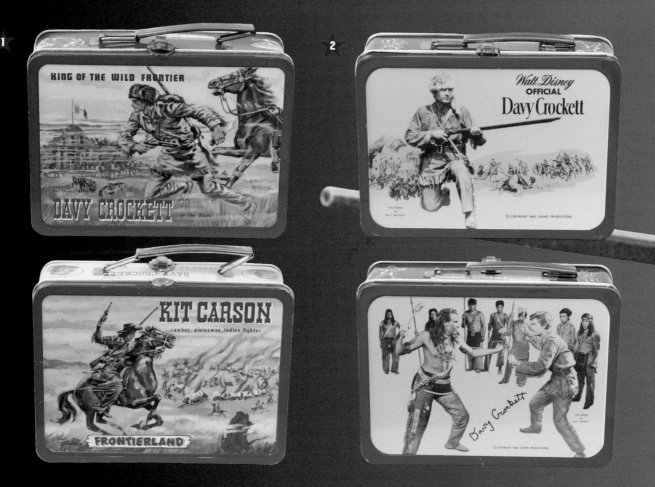

A beloved character in American mythology, Davy Crockett was once a real frontiersman before he became a hugely popular Disney character. As a result, Crockett became a much-coveted property for lunchbox manufacturers. Originally licensed by ADCO, the company inexplicably decided Kit Carson belonged on the back of the Crockett box *(above, left)*. But Carson wasn't a Disney character,

and Disney didn't want him to share billing with their character. So Disney yanked the rest of their properties away from ADCO.

In his time, Davy Crockett was *big*, as big as the Beatles and Hula Hoops. Disney desperately tried to squelch unauthorized boxes, like one manufactured in Canada *(above, right)*. Its maker, The Kruger Manufacturing Company, normally

produced flashlights and tackle boxes, but decided mid-fad to jump on the Davy Crockett bandwagon. It was the only lunchbox they made. The Davy Crockett thermoses *(opposite page)*, produced by Universal, are among the rarest and most pricey in the entire lunchbox market, with reportedly only a dozen or so in existence.

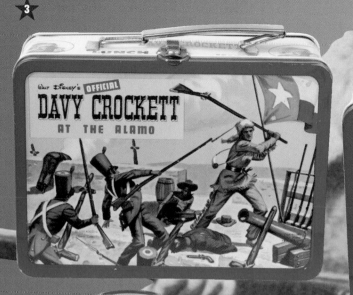

1. *Davy Crockett and Kit Carson*
 ADCO/Universal, 1955
 $$

2. *Walt Disney Official Davy Crockett*
 The Kruger Manufacturing Company, Canada, 1955
 $$$$

3. *Davy Crockett at the Alamo (front) and Indian Fighter (back)*
 Universal, 1955
 $$$$

4. *Davy Crockett thermoses*
 Universal, 1955
 $$$$$

During the Davy Crockett fad, Aladdin designed a Daniel Boone box so it could throw its own coonskin hat into the ring. Prototypes of the box were made and copyrighted, but Aladdin marketers decided they didn't want to permanently alienate Disney, so they left the design on ice. However, ten years later, Disney produced the *Daniel Boone* TV show. When rival King Seeley was given the lunchbox concession, Aladdin released the original copyrighted Daniel Boone box *(left)* and sued its rival, forcing it to recall its boxes and reissue them with the clunky wording "Fess Parker Lunch Kit from the Daniel Boone TV Show" *(below)*.

1. *Daniel Boone*
 Aladdin, 1965
 $$$

2. *Fess Parker Lunch Kit from the Daniel Boone TV Show*
 King Seeley, 1965
 $$$

3. *Pathfinder*
 Universal, 1959
 $$$

4. *Back in '76*
 Aladdin, 1975
 $

3

Make way for the U.S. Bicentennial! The Back in '76 box *(right)* shows a caricature of Founding Father George Washington eyeing closely the work of a very 1970s-looking shoe-shine boy. The back shows Paul Revere galloping through the Massachusetts countryside before being captured at a British checkpoint; the sides show a cartoon rendition of John Hancock and the boys signing the Declaration of Independence.

4

Smokey Bear is, of course, the most famous spokesanimal for fire prevention. He had his own lunchbox, but not before a few false starts. Ardee had licensed the rights to Smokey and built a handful of prototypes *(above, left)*, of which only two are thought to be in existence. However, the company dawdled too long and the rights were taken away and granted to King Seeley/American Thermos *(above, right)*.

1. **Smokey Bear**
 (prototype—box never manufactured)
 Ardee, mid-1960s
 $$$$$

2. **Smokey**
 King Seeley, 1960s
 $$$

3. **Smokey Bear**
 Universal, 1975
 $$$

The Mounties always get their man. Or, as depicted on the Canadian School Days lunchbox *(right)*, they always get their kid who's skipping school. Funny, you don't usually think of the Mounties as practicing police brutality against kids and minorities. O Canada!

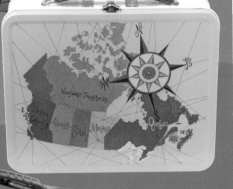

12

GIRL POWER

SUGAR, SPICE & A MARKETER'S NIGHTMARE

Thank heaven for little girls. Who else had the power to bedevil lunchbox makers? Flummoxed by the age-old question posed by Sigmund Freud—What do women want?—manufacturers quickly discovered that boys were easier to sell to. Television shows and movies were abundant with boy-related themes—cars, police, combat, cowboys, and sports—but girls remained a marketing mystery.

It didn't help that lunchbox manufacturers were overwhelmingly men. In the entire Aladdin Company, for example, there was exactly one woman in any position of power working in research and development. A clueless design team had to settle for showing prototypes to the "gals" in the typing pool. "We were pretty dumb about it," recalls one designer. "Usually the secretaries would just shake their heads."

Ultimately, designers decided to appeal to female sensibilities with time-honored icons of girlhood: flowers, doll faces, cool teens, boy bands, and puppy dogs. For older girls, they hit upon the idea of making boxes in various shapes, including purse-shaped vinyl "Brunch Bags" with trendy little shoulder straps. The real trump card, however, was a licensing deal struck by the Mattel Corporation and American Thermos in the 1960s: the creation of Barbie lunchboxes, which sold millions of boxes a year.

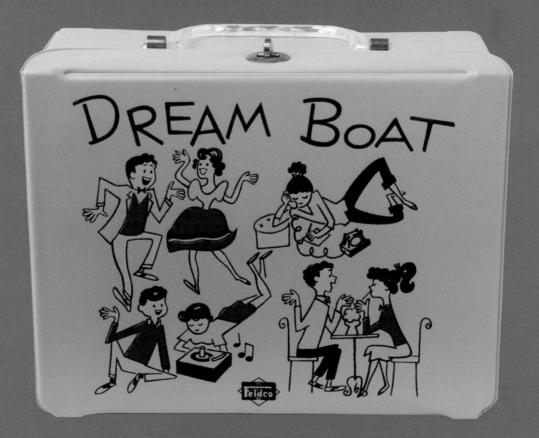

Grace Drayton Wiederseim, the wife of a Campbell's advertising executive and a well-known illustrator, first drew the Campbell Soup Kids in the early 1900s. She took the children's wide-eyed, pudgy, red-cheeked faces from her own likeness in the hope of convincing moms that soup-slurping kids would be healthy and hearty. Campbell's continued to update and use her images for nearly a century, including those on this lunchbox from the 1950s. Considering the brand being advertised, you'd think they'd have made the thermos a lot bigger.

1

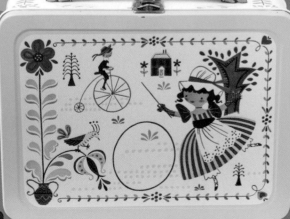

Despite its name, there was nothing particularly Holland-like about this Little Dutch Miss lunchbox *(below)*—no wooden shoes, no windmills, no little boys with fingers in dikes. However, at the time, designs from the Pennsylvania Dutch were popular, and this box mimicked some of those characteristics. (Incidentally, the Pennsylvania Dutch were in fact German. English-speaking settlers heard "Dutch" when the Germans identified themselves as "Deutsch.")

1. *Campbell's Soup Kids*
 Universal, 1959
 $$

2. *Little Dutch Miss*
 Universal, 1959
 $

3. *Barbie and Midge*
 American Thermos, 1964
 $$

4. *Deb-U-Teen*
 Hasbro, early 1960s
 $$

2

Midge, introduced in 1963, is Barbie's oldest friend. Unlike Barbie, who remained a carefree single girl over the next forty years, Midge got married to Ken's friend, Alan, in 1991. In 2002, she generated controversy among concerned mothers by getting herself knocked up. Her doll came with a detachable magnetic belly with a curled-up baby inside (if only real-life childbirth were so easy!). This Canadian Barbie and Midge metal box—sporting a design used for a vinyl box in the U.S.—is not as common in the States as most other Barbie boxes. Aladdin Company personnel, by the way, suffered great remorse because they were offered the license for Barbie first, but turned it down.

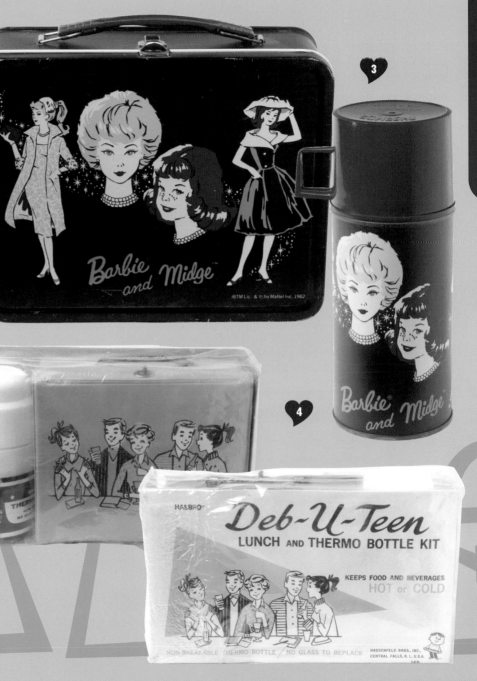

King Seeley issued two boxes with games on the back. Auto Race marketed to boys and Campus Queen *(right)* aimed at girls who couldn't wait to grow up and be teenagers. Similar to the popular board game Life, Campus Queen offered young girls an opportunity to vicariously experience teen activities: "Your date asks you to the movies. Move ahead to theater," and "You need a hairdo for the prom. Go back to beauty parlor."

CAMPUS QUEEN

MAGNETIC GAME KIT.

OHIO ART

color me happy

MY LUNCH BOX

when it's lunch time

1. *Campus Queen*
 King Seeley, 1967
 $$

2. *Color Me Happy*
 Ohio Arts, 1984
 $$

3. *Dream Boat*
 Feldco, 1960s
 $$$$

4. *Miss America*
 Aladdin, 1972
 $

DREAM BOAT

feldco

The Dream Boat, a blissful depiction of a schoolgirl's crush, came in three colors: white, brown, and blue *(above)*, each with the same tableau. Precious few of these boxes are around today (one collector says that in the entire world of lunchbox dealers there are only eighteen Dream Boats known: ten brown, six white, and two blue), making this a rare and very valuable specimen.

Miss America

13

KIDS' STUFF

SOMETHING FOR THE LITTLE PEOPLE

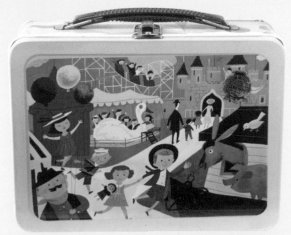

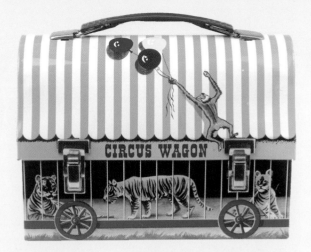

Historically, the demographic of lunchbox owners peaked at around fourth and fifth grade. Younger kids tended to get brown bags or whatever boxes were chosen for them; it often took several years of wheedling until parents were worn down enough to buy Rambo, or the Monkees, or whatever box their kid wanted. And then within a couple of years, adolescence would force the lunchbox into preteen oblivion—along with everything else dorky. In other words, kids had precious little time to exercise their purchasing power over lunchbox design in any meaningful way.

This narrow window of opportunity was a challenge and frustration to manufacturers. In response, they tried to redefine the limits of lunchbox ownership, creating vinyl bags for teen girls that were just as likely to be used as purses and, for the younger set, little-kid boxes that no self-respecting fourth-grader would be seen carrying. Here are some of the best.

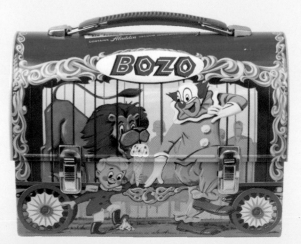

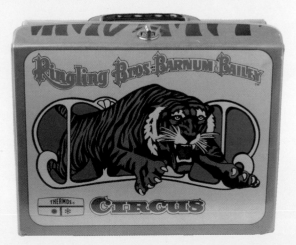

If anyone at Aladdin worried that a breakfast cereal on a lunchbox might confuse matters, kids apparently didn't mind. The design featured most of the Kellogg's cereals with their cartoon mascots, including Tony the Tiger on the front, Snap, Crackle & Pop on the back, and the Corn Flakes rooster, the Froot Loops toucan, and the Apple Jacks apple on the sides and thermos. Aladdin nixed one idea, though—Kellogg's wanted to include cereal samples inside, but the lunchbox company feared their warehouses would get infested with weevils and other vermin.

2

1. **Kellogg's Frosted Flakes**
 Aladdin, 1969
 $$$

2. **Fritos**
 King Seeley, 1975
 $$

3. **CrackerJack**
 Aladdin, 1969
 $

4. **Ronald McDonald:**
 Sheriff of Cactus
 Canyon
 Aladdin, 1982
 $

Notice any similarity between the McDonaldland characters *(below, right)* and the Sid and Marty Krofft characters in *H.R. Pufnstuf* (see page 6)? Well, the Kroffts did. They sued McDonald's for copyright infringement and won a settlement of $50,000 from the corporate burger slinger.

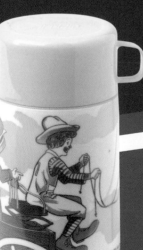

T he talented and pretty ventriloquist Shari Lewis made a good living supplying the voices to her famous sock puppets, Lamb Chop, Hush Puppy, and Charlie Horse *(right)*. She made regular appearances performing more grown-up material on variety shows (like *The Ed Sullivan Show*), and had her own children's programs through the 1950s into the 1960s, and again on PBS through most of the 1990s, winning twelve Emmys and a Peabody Award.

1. *Shari Lewis and Her Friends*
 Aladdin, 1963
 $$$

2. *Jim Henson's Muppet Babies*
 King Seeley, 1985
 $

Bob Keeshan, the first Clarabell the Clown on *The Howdy Doody Show*, was fired in 1953 when he and four other cast members asked for higher pay. In 1955, the twenty-eight-year-old Keeshan became the beloved, gentle Captain Kangaroo, and his show ran on CBS from 1955 to 1984 (and was later revived on PBS). The lunchbox below shows the Captain, Dancing Bear, Mr. Green Jeans, and Grandfather Clock, but not, for some reason, two main characters, Mr. Bunny Rabbit and Mr. Moose. Perhaps they, too, demanded higher pay?

3. **Jack and Jill**
Ohio Arts, 1982
$$$

4. **Captain Kangaroo**
King Seeley, 1964
$$$

For his children's illustrations, Theodor Seuss Geisel used his middle name, adding the honorific "Dr." because he thought it made him sound more authoritative. Apart from bearing the same design on the metal and vinyl versions, these boxes *(right, and below)* were both designed by the good doctor himself—an unusual distinction not even accorded Charles Schulz.

THE WORLD OF
Dr. Seuss

THE WORLD OF
Dr. Seuss

1

2

THE WORLD OF
Dr. Seuss

THE WORLD OF
Dr. Seuss

THE WORLD OF
Dr. Seuss

1. *The World of Dr. Seuss*
 (vinyl)
 Aladdin, 1970
 $$$

2. *The World of Dr. Seuss*
 (both sides)
 Aladdin, 1970
 $$$

3. *Little Friends*
 Aladdin, 1982
 $$$$

4. *Winnie the Pooh*
 Aladdin, 1967
 $$

3

What small kid could say no to the idea of carrying along a little puppy, a kitty, and big-eyed woodland creatures to school with them? That was the lure of the Little Friends lunchbox *(left)*. You just better make sure you remember to cut air holes in that box, Jimmy. You don't want a dead puppy, do you?

4

What kid doesn't like a circus? Well, true, a lot of them are easily frightened by feral animals and manic clowns. Still, lunchbox manufacturers decided that a circus motif was just the ticket to get into the center ring of a kid's heart. Not surprisingly, Bozo, the most merchandised clown in history, had his own lunchbox *(right)*. It was a more innocent time; modern folks might wonder why he was constantly accompanied by a young companion he called "Butchy Boy."

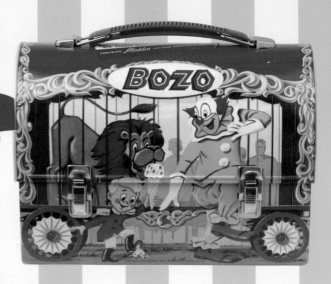

1

2

1. *Bozo*
Aladdin, 1963
$$$

2. *Circus Wagon*
American Thermos, 1958
$$

3. *Carnival*
Universal, 1959
$$$

4. *Ringling Bros. and Barnum & Bailey Circus*
King Seeley, 1970
$$

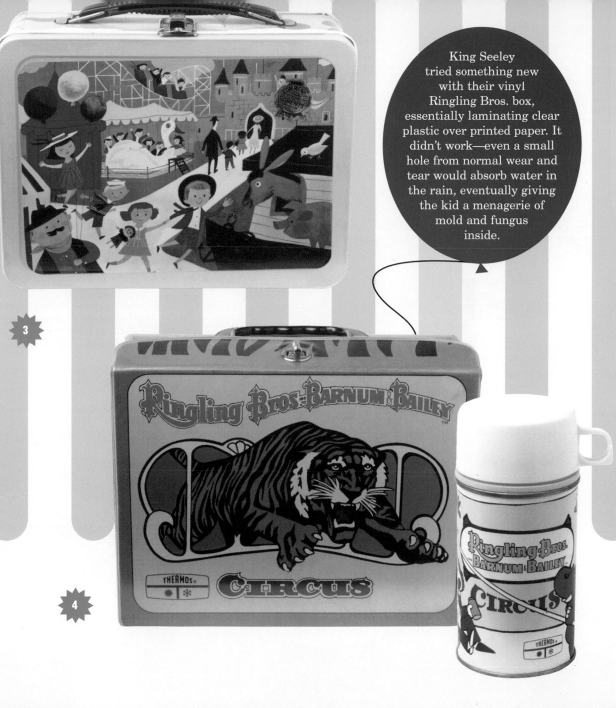

King Seeley tried something new with their vinyl Ringling Bros. box, essentially laminating clear plastic over printed paper. It didn't work—even a small hole from normal wear and tear would absorb water in the rain, eventually giving the kid a menagerie of mold and fungus inside.

3

4

Although "Disney World on Ice" reminds one of those rumors about a cryogenically frozen Walt, the box in fact commemorates the traveling show, which began in 1981 with one touring company. At latest count, there are five North American and two international World on Ice troupes, each starring hundreds of people dressed as Disney characters.

1

Walt Disney
SCHOOL BUS

2

DISNEY on PARADE

3

Walt Disney PRODUCTIONS' WORLD on ICE

Walt Disney's Wonderful World

The Disney School Bus, the longest-running lunchbox in history, was on the market for a record twelve years, from 1961 to 1973. It was also the bestselling one in history—six million sold. You can see why—playful and bright, it had an optimal design for its dome shape. At first glance, the two Disney buses pictured here *(opposite page left, and below)* look the same, but there are subtle differences, most notably the fact that one of the three little pigs is exiting instead of Jiminy Cricket. The School Days lunchbox *(left)*, featuring Professor Mickey, was produced only for export; rarely found in the United States, it remains highly sought-after by collectors.

1. **Walt Disney School Bus**
 (Spanish import)
 Payva, 1960s
 $$$

2. **Disney on Parade**
 Aladdin, 1970
 $

3. **Walt Disney Productions World on Ice**
 Aladdin, 1982
 $

4. **"School Days"**
 Aladdin, 1984
 $$$

5. **Walt Disney School Bus**
 Aladdin, 1961
 $

14

WHAT WERE THEY THINKING?

LUNCHBOXES FROM ANOTHER PLANET

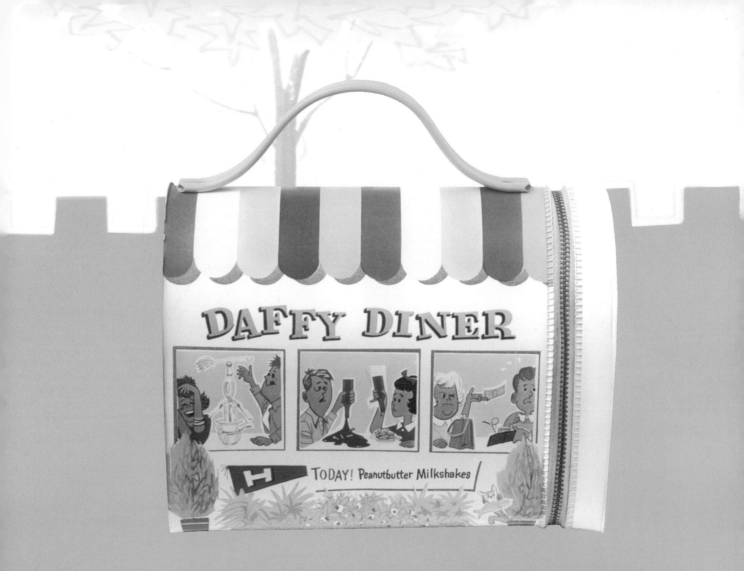

TODAY! Peanutbutter Milkshakes

I n this final chapter, we wanted to present some of the lunchboxes we came across that made us scratch our heads, or slap our foreheads and ask, "What were they thinking?" These boxes seem inspired by a different set of marketing rules—or no rules whatsoever. Although some are quaint or kitschy enough to be sought by collectors, at least a few of these are truly bizarre. For example, there's this zipper vinyl Daffy Diner box *(above)* or the ones that seem to encourage eating disorders, cannibalism, bestiality...you'll see what we mean.

For much of a decade, disco was a force to be reckoned with. Launched in black and gay nightclubs in the early 1970s, disco hit the mainstream middecade...and by 1979, it was pretty much a dead fad that everybody was sick of. So it's hard to imagine what the people at American Thermos were thinking when they brought this one *(right)* out in late 1980.

DISCO FEVER

1

2

Gentle Ben

ALADDIN INDUSTRIES INCORPORATED NASHVILLE TENN USA

Gentle Ben

Gentle Ben

Gentle Ben starred Dennis Weaver, Clint Howard (Ron Howard's brother), and a bear. It's about an eight-year-old boy in the Florida everglades who saves a bear cub from being killed and adopts it. Although it's a sweet story, the artwork on the tie-in lunchbox implied a relationship between boy and bear that was, well...way too intimate.

1. *Disco Fever*
 American Thermos,
 1980
 $

2. *Gentle Ben*
 Aladdin, 1968
 $$

3. *Jonathan
 Livingston Seagull*
 Aladdin, 1973
 $

3

Jonathan Livingston Seagull was a groovy 1970s book by Richard Bach about a New Age seagull in search of "a perfect flight" and a higher purpose beyond transportation and seeking food. The book was aimed at college students and adults who were getting in touch with their inner souls and aiming for some sort of personal transcendence. Whatever childlike qualities the gull had, the story was not aimed at children. (The movie featured a soundtrack by Neil Diamond, for God's sake.) Perhaps this lunchbox was meant for someone's inner child, but it didn't sell so well among the school-age set.

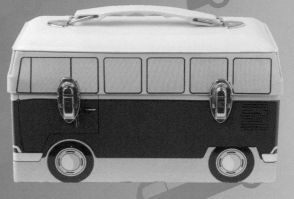

"Let's make a lunchbox with generic-looking, everyday icons. It'll be just like Andy Warhol and those pop-art guys! The kids'll love it." Well, the kids didn't. A lunchbox that looks like a loaf of bread *(above)*? Another with a flattened view of a VW bus *(right)*? They might've been a hit with trendy urbanites, but these ideas went right over the little kids' heads.

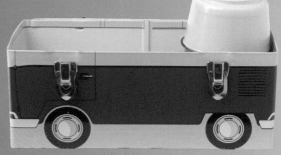

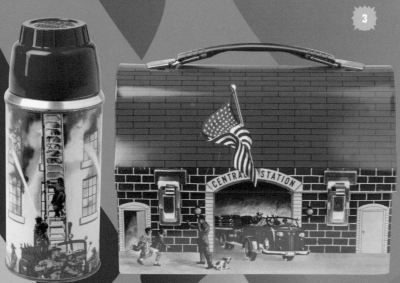

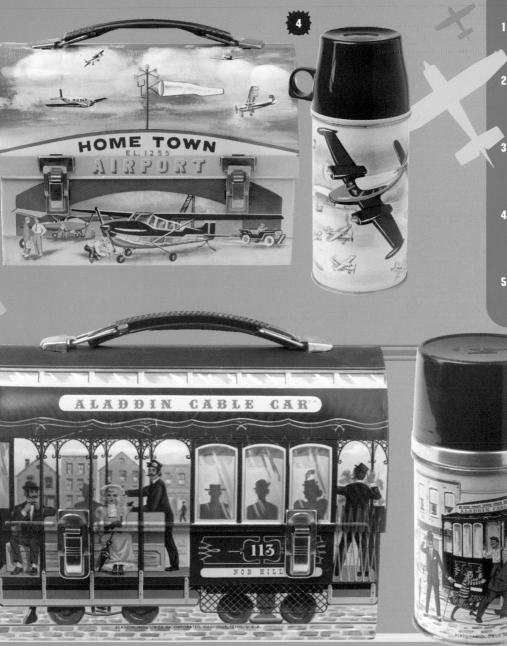

1. *Bread Loaf*
 Aladdin, 1968
 $$

2. *VW Bus*
 Omni Graphics,
 early 1960s
 $$$$

3. *Central Station*
 American Thermos,
 1959
 $$

4. *Home Town*
 Airport
 Aladdin, 1960
 $$$$

5. *Aladdin Cable Car*
 Aladdin, 1962
 $$$

Hey, kids, how'd you like to send those leftovers home via the postman? Who knows what inspired the U.S. Mail lunchbox *(below)*, sporting an inexplicable cancellation mark from Austin, Texas? Perhaps slightly more plausible was the Treasure Chest *(right)* from the early 1960s. Looking very similar to the more popular and famous Buccaneer box (see page 132), it apparently safeguarded priceless cold cuts and Hostess Sno Balls.

1

TREASURE CHEST

2

SPECIAL DELIVERY

STILL ON

U.S. MAIL

POSTAGE DUE

PAR AVION

AUSTIN
DEC 3
2 PM
TEXAS

DO NOT BREAK

S.W.A.B.K.

FRAGILE

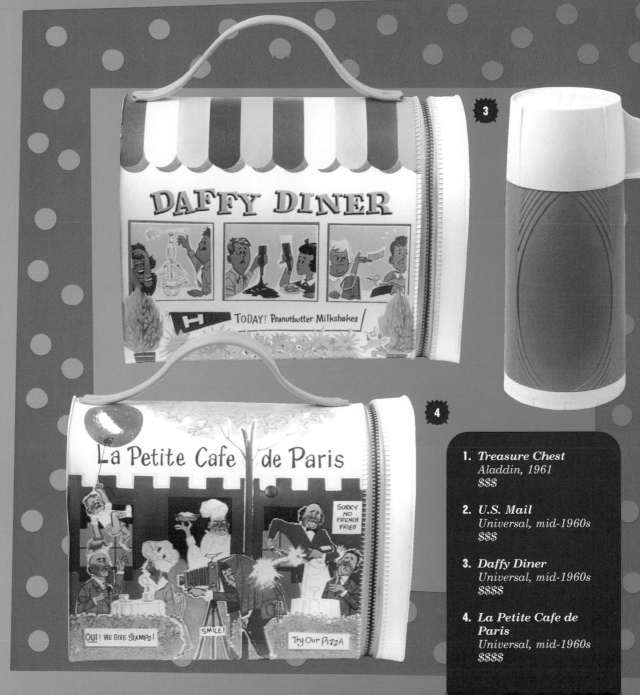

1. *Treasure Chest*
 Aladdin, 1961
 $$$

2. *U.S. Mail*
 Universal, mid-1960s
 $$$

3. *Daffy Diner*
 Universal, mid-1960s
 $$$$

4. *La Petite Cafe de Paris*
 Universal, mid-1960s
 $$$$

Believe it or not, the Twiggy brunch bag *(right)* was big enough to hold not only a single carrot, but a sandwich and thermos, too! In the days before anorexia became every mother's worst fear for her daughters, this Twiggy box flew off the shelves. Little girls wanted to be just like the glamorously emaciated fashion model.

In case being matchstick-thin wasn't your thing, though, there were other options for those wanting a reminder of their favorite eating disorder: for example, gluttony! The Fat Albert lunchbox *(below)* and Porky's Lunch Wagon box *(opposite page, above)* featured obesity as a lovable character trait. And don't forget cannibalism! *V (opposite page, below)* was a sci-fi show in which the lizard-like invaders came to earth disguised as people looking for cheap protein of the *Homo sapiens* variety. Not necessarily the sort of idea you want to plant in the impressionable mind of a famished youngster.

1

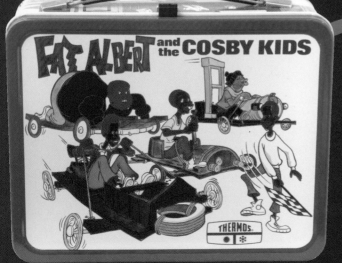

2

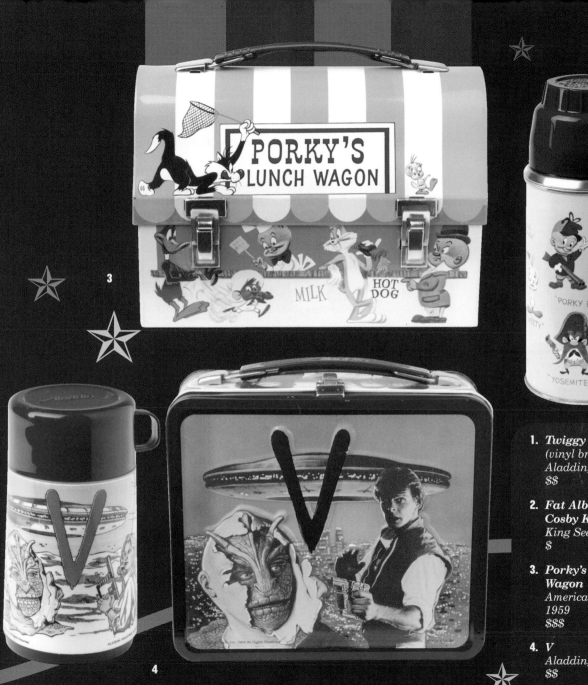

1. **Twiggy**
 (vinyl brunch bag)
 Aladdin, 1967
 $$

2. **Fat Albert and the Cosby Kids**
 King Seeley, 1973
 $

3. **Porky's Lunch Wagon**
 American Thermos, 1959
 $$$

4. **V**
 Aladdin, 1984
 $$

ACKNOWLEDGMENTS

The authors gratefully acknowledge Joe and Lois Soucy for providing the collection featured within and having the patience to allow us into their house to photograph it. We would also like to thank Harold Dorwin of the Smithsonian Institution; Dave Burgevin, Smithsonian Photographic Services; Brian Heiler and the Mego Museum; and Allen Woodall. Special thanks to Christopher Sweet.

Produced by HERE+THERE for HarperEntertainment, an imprint of HarperCollins Publishers

Joe Dolce, editorial director
Caz Hildebrand, creative director
Paul Brissman, photographer
Chris Knutsen, project editor
John Bennett, assistant editor
Joe Soucy, Seaside Toys, (401) 596-0962
Kate Marlow, designer
Julie Martin, designer
Mark Paton, designer
Arran Scott Lidgett, cut-outs

www.hereandtheregroup.com

HarperCollins books may be purchased for educational, business, or sales promotional use. For information please write: Special Markets Department, HarperCollins Publishers Inc., 10 East 53rd Street, New York, NY 10022.

FIRST EDITION

Library of Congress Cataloging-in-Publication Data

Mingo, Jack, 1952–
 Lunchbox: inside and out / Jack Mingo, Erin Barrett. — 1st ed.
 p. cm.
 ISBN 0-06-059519-1
 1. Lunchboxes—Collectors and collecting—United States—Catalogs. I. Barrett, Erin. II. Title.

NK6213.M54 2004
676.'34—dc22
 2004040637

04 05 06 07 08 10 9 8 7 6 5 4 3 2 1